Mom....
Merry Christmas
2006!
Love Julie

Above the North

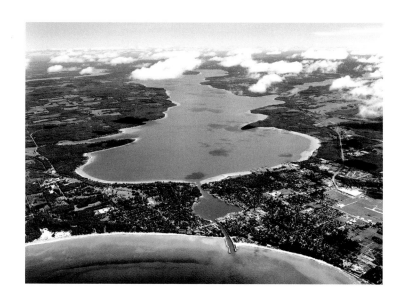

Charlevoix

Above the North

AERIAL PHOTOGRAPHY OF NORTHERN MICHIGAN BY MARGE BEAVER

University of Michigan Press
Ann Arbor
&
Petoskey Publishing Company
Traverse City

Published in the United States of America by

The University of Michigan Press

&

The Petoskey Publishing Company

Manufactured in Canada by Friesens

2009 2008 2007 2006 4 3 2 1

ISBN-13: 978-0-472-11549-5 (cloth : alk. paper)

ISBN-10: 0-472-11549-9 (cloth : alk. paper)

Library of Congress Cataloging in Publication Data on file

INTRODUCTION

Marge Beaver bought her first plane in 1982 to meld her two passions, flying and photography. Now, after 25 years and close to 7000 hours later as pilot and photographer, she still thoroughly enjoys trying to produce those amazing images that just aren't normally seen. A slumping winter dune at Sleeping Bear, a path cut through the ice and underneath the Mackinac Bridge, fall colors that take your breath away and amazing blues, greens and whites along our shoreline—images that make you pause in amazement as you study the photographs in more detail. As you look through the pages, you will see that Marge Beaver's love of how Michigan looks from the air shows in her photos.

Marge is someone of few words, unless of course you subscribe to the belief, "A picture is worth a thousand words." If so, Marge Beaver's work speaks volumes.

"I have flown all over the country for hundreds of customers, taking pictures in nearly every state, and Michigan is still my favorite place to live, fly and photograph. It just doesn't get any better; the lakes, the dunes, the harbors, the forests; we have it all, and I am excited to share the incredible views I get to see when I am flying.

"One of the special things about doing this book is that I was offered an excuse to try and be even more artistic with the photographs, capturing the lakes and rivers and orchards, ice flows and even a simple view of hay bailing that I hope will give the moments pause, or even longer, to appreciate our great state."

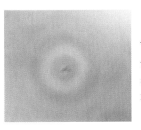

The Glory
When you are flying over clouds when the sun is shining, looking out the window in the right direction, you will see the shadow of the airplane on the clouds, surrounded by a "rainbow" circle. It is what nearly every pilot has seen, and hopefully, someday you will, too.

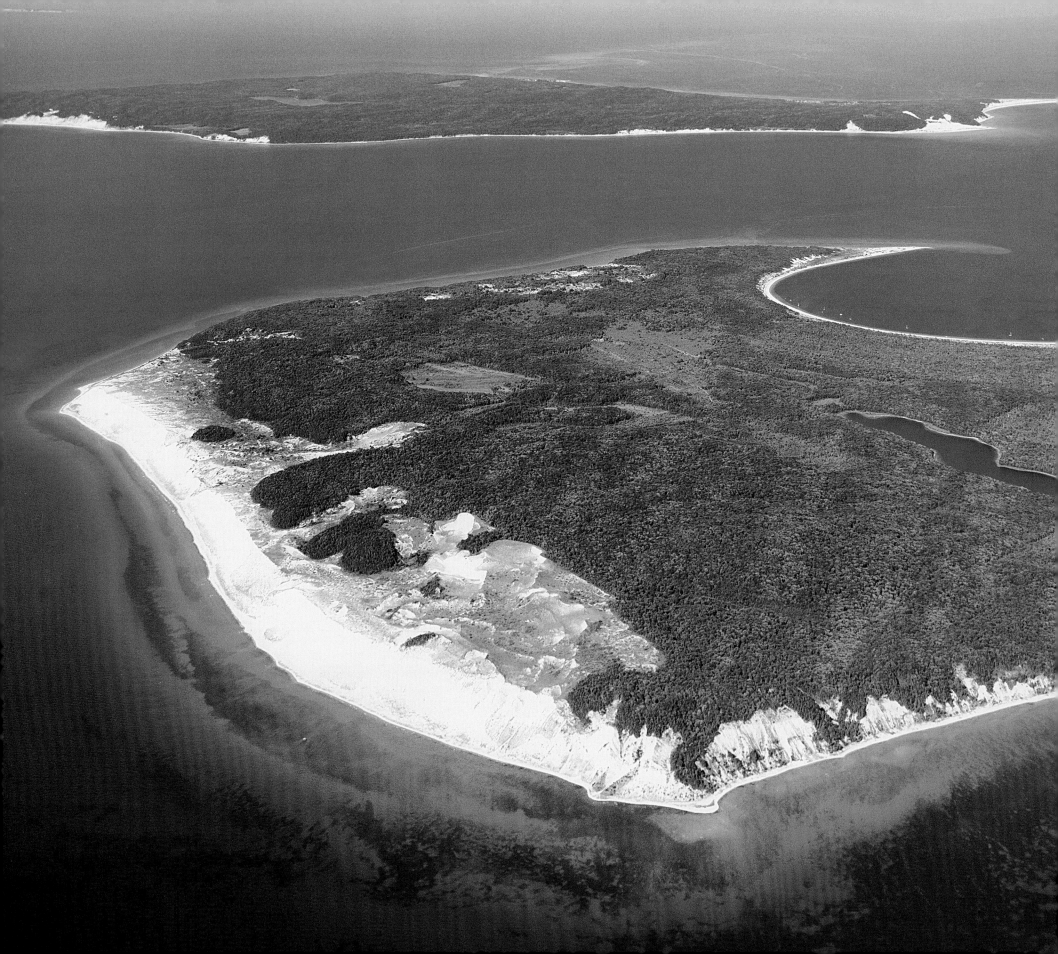

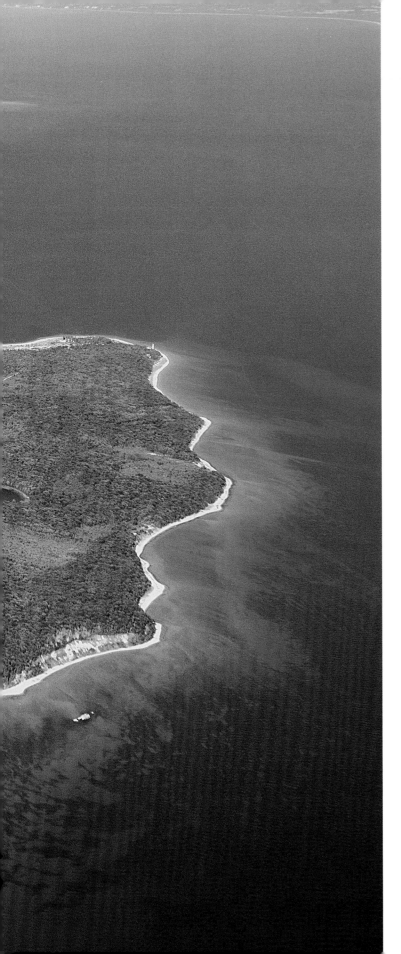

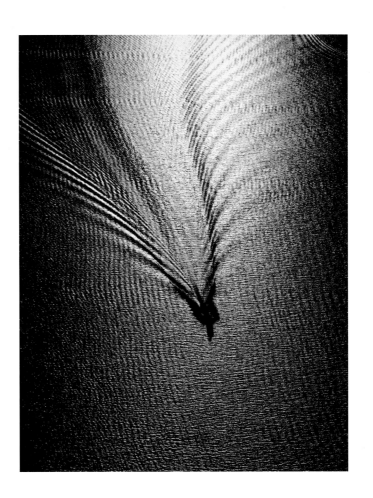

Boat on Lake Charlevoix

South Manitou Island

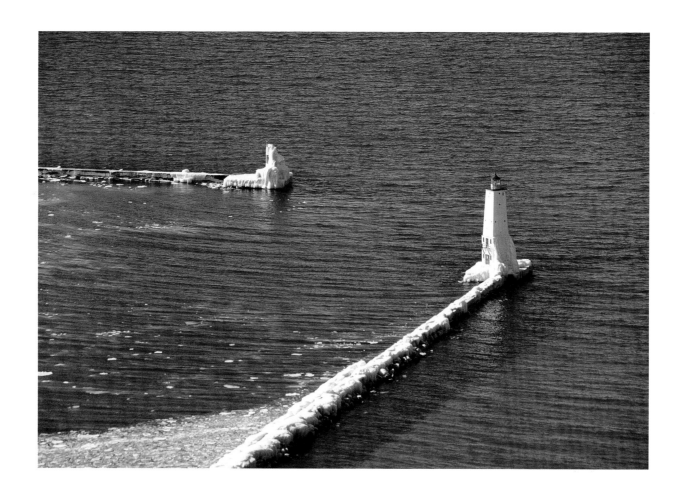

Frankfort Lighthouse

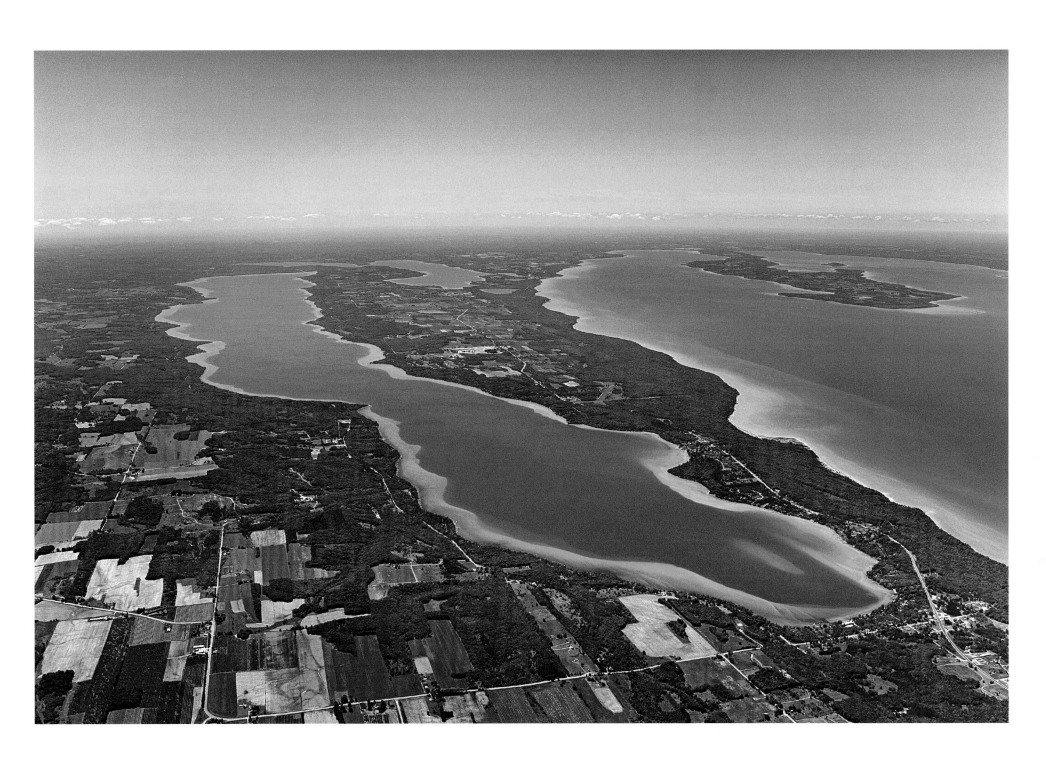

Torch Lake

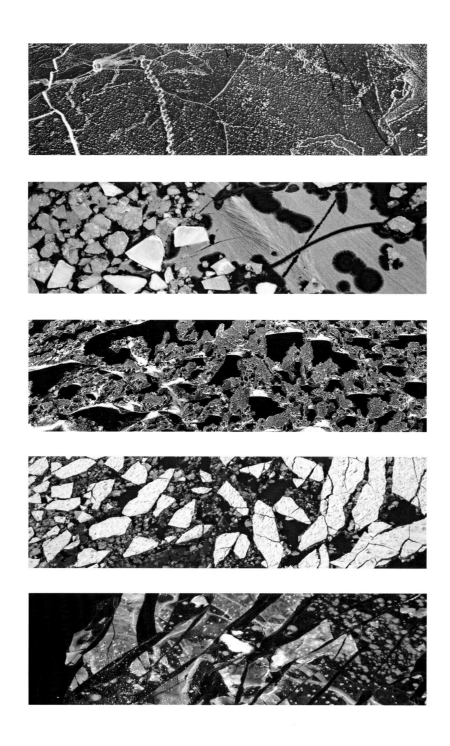

Ice on Lake Michigan

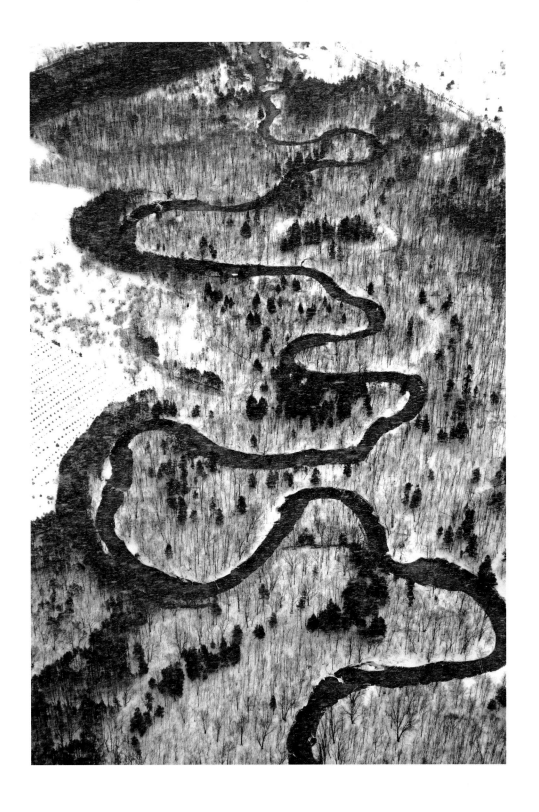

River Oxbows

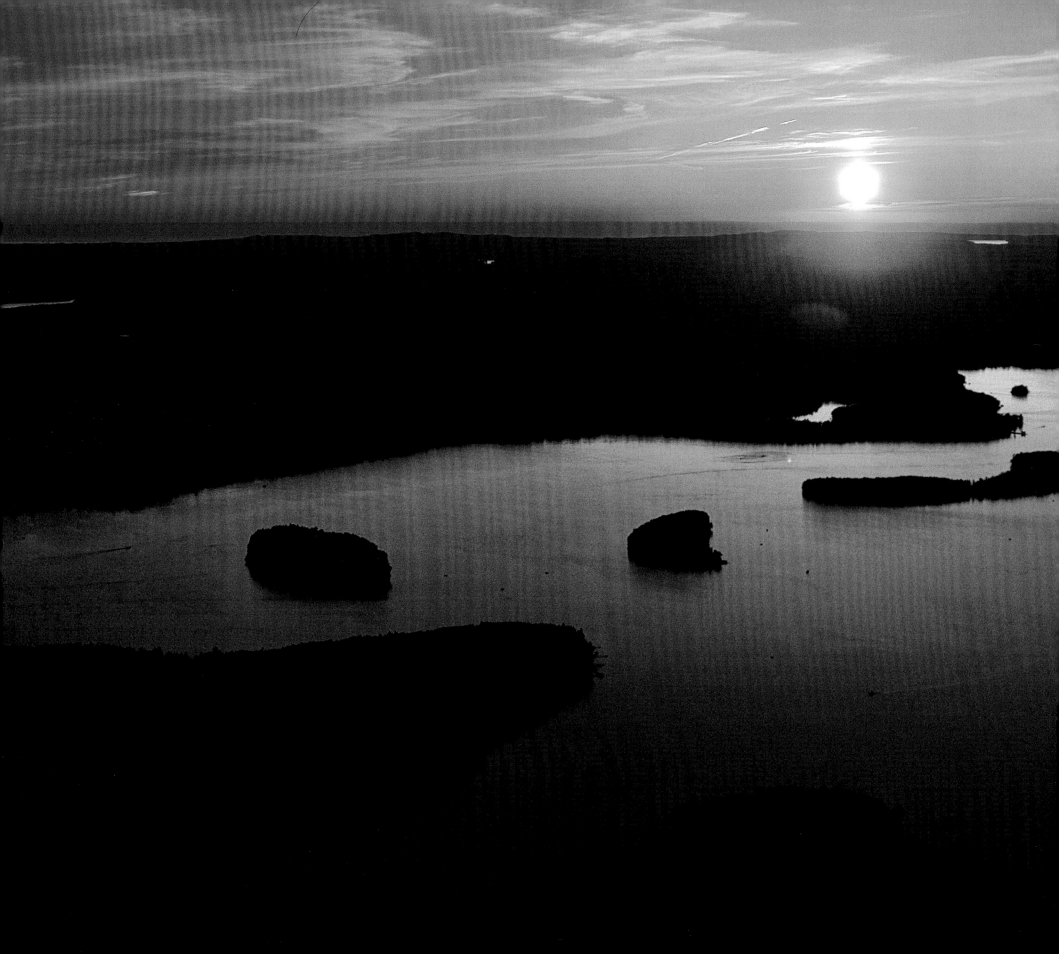

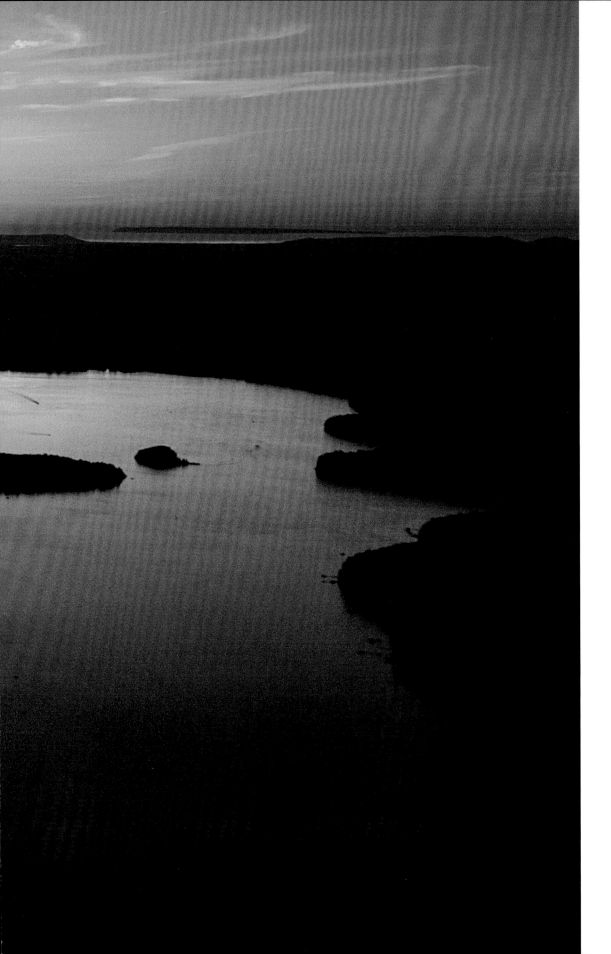

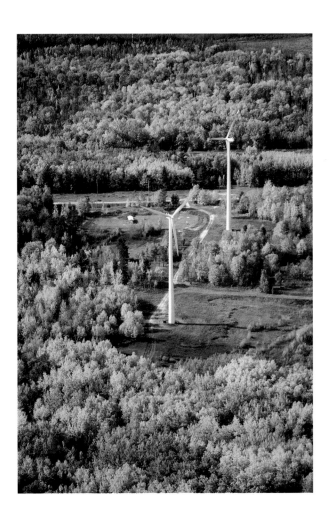

Mackinaw City wind turbines

Long Lake sunset

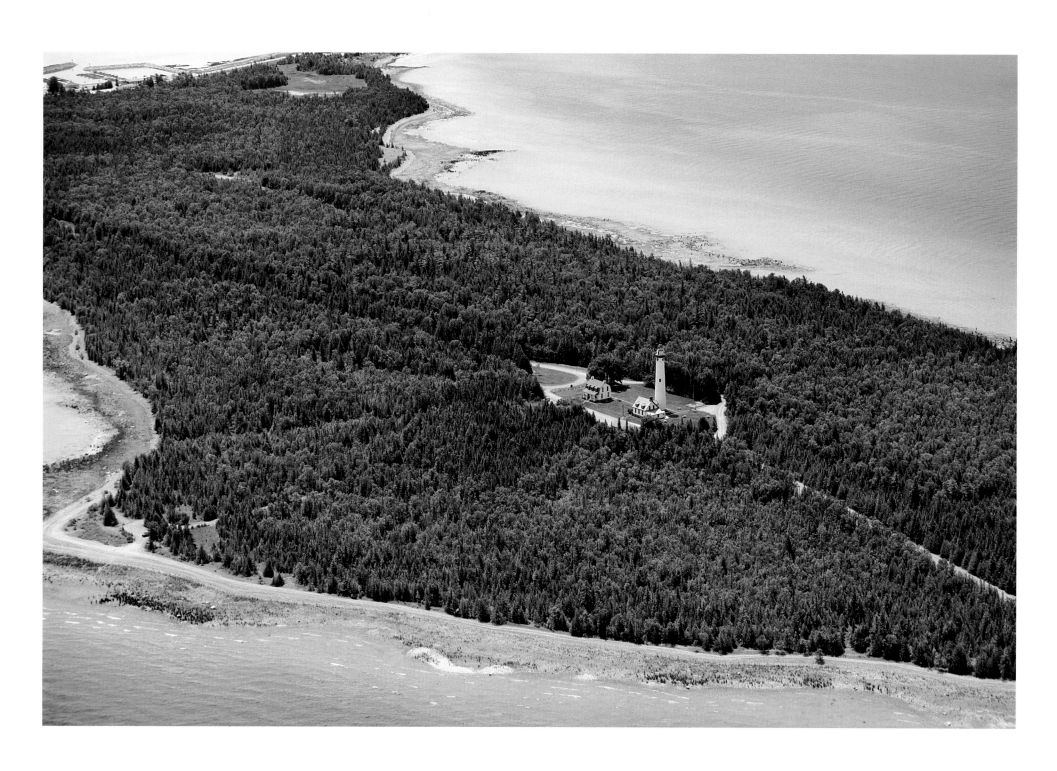

New Presque Isle Lighthouse

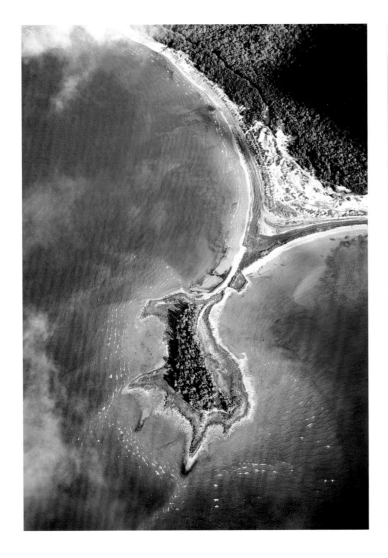

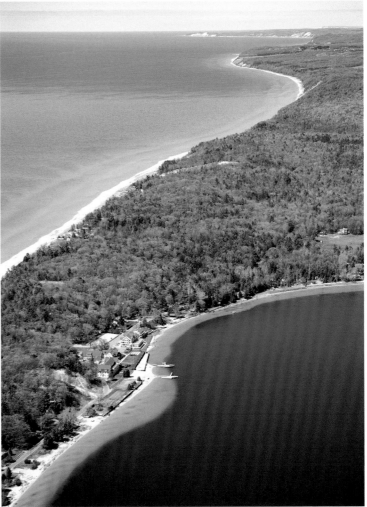

Fisherman's Island

Onekama

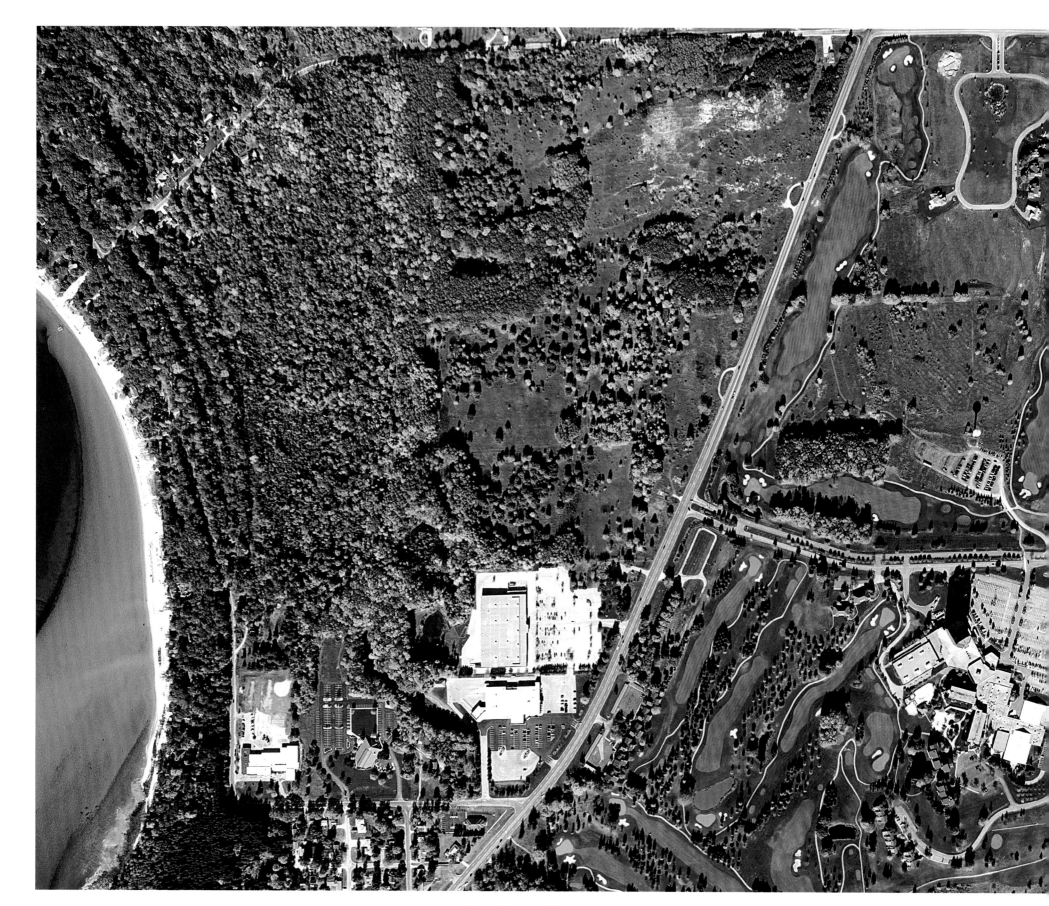

Grand Traverse Resort

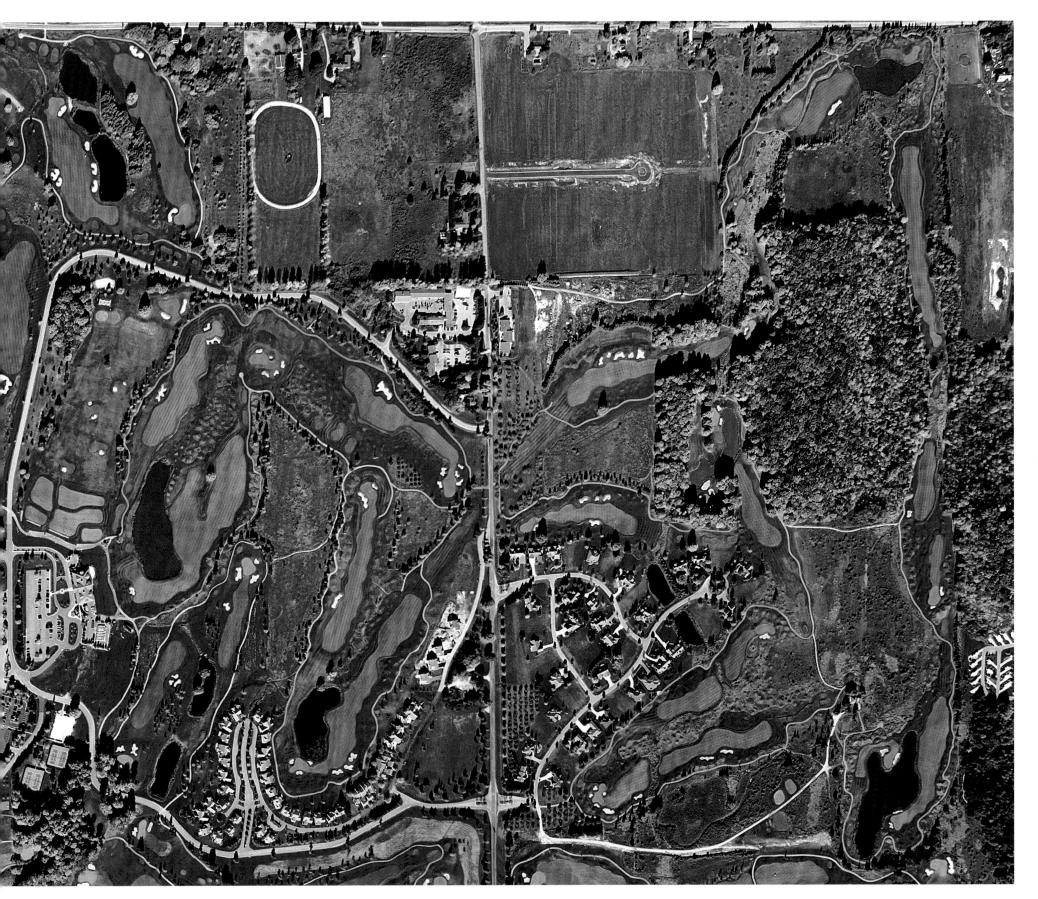

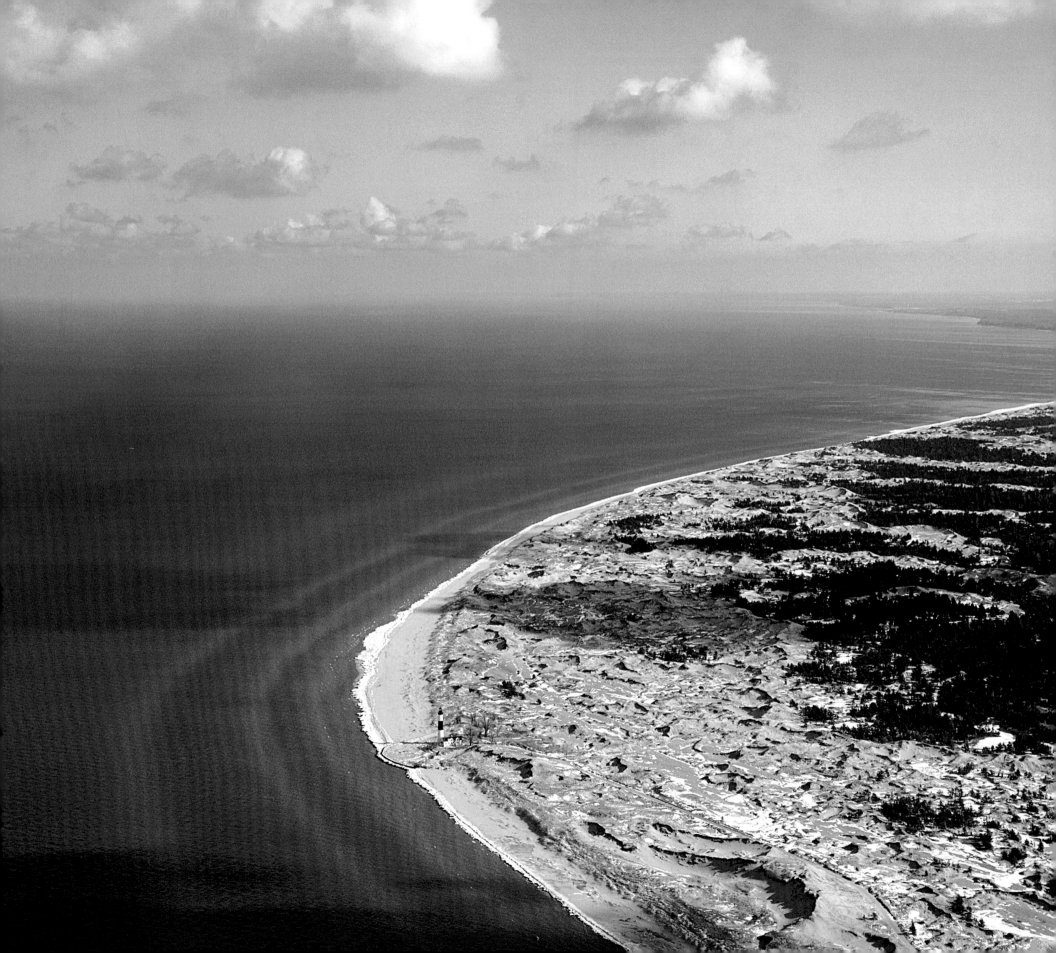

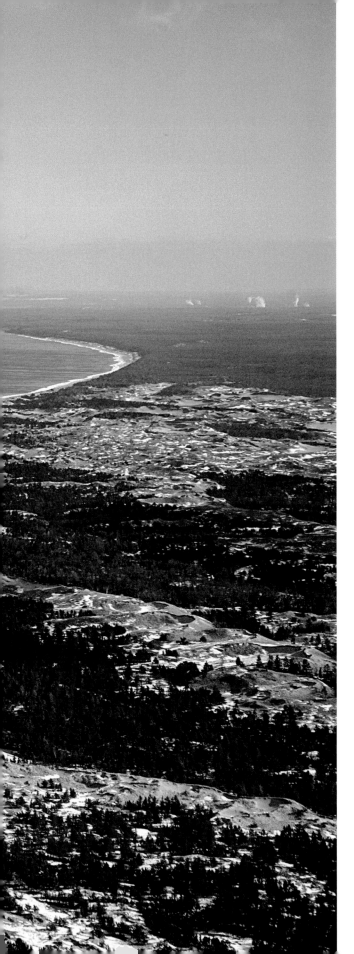

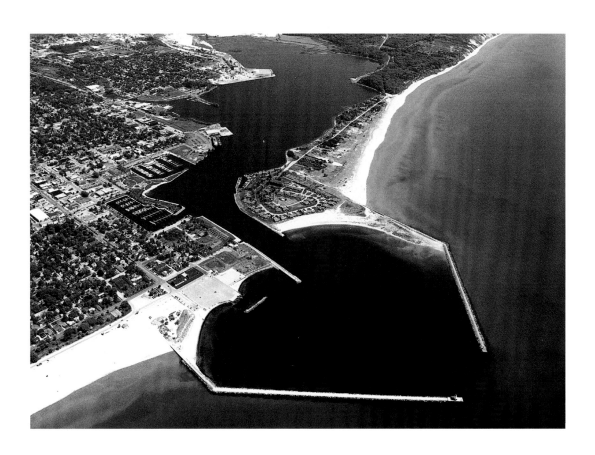

Ludington

Ludington State Park

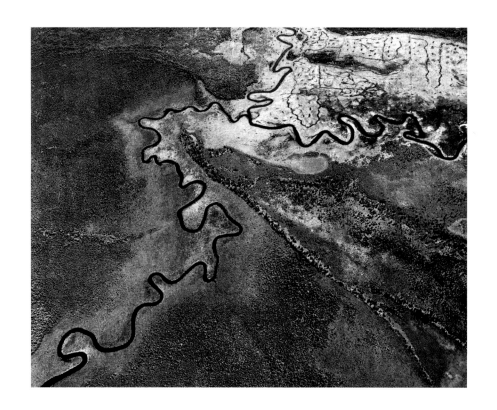

Dead Stream Swamp

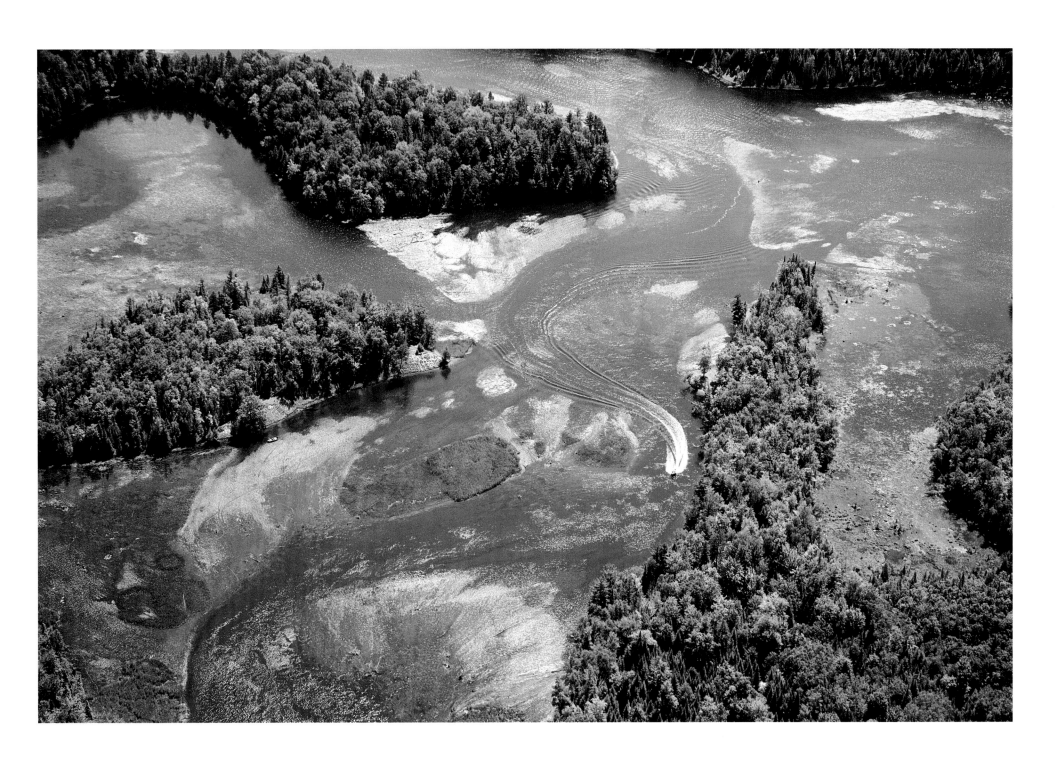

Au Sable River

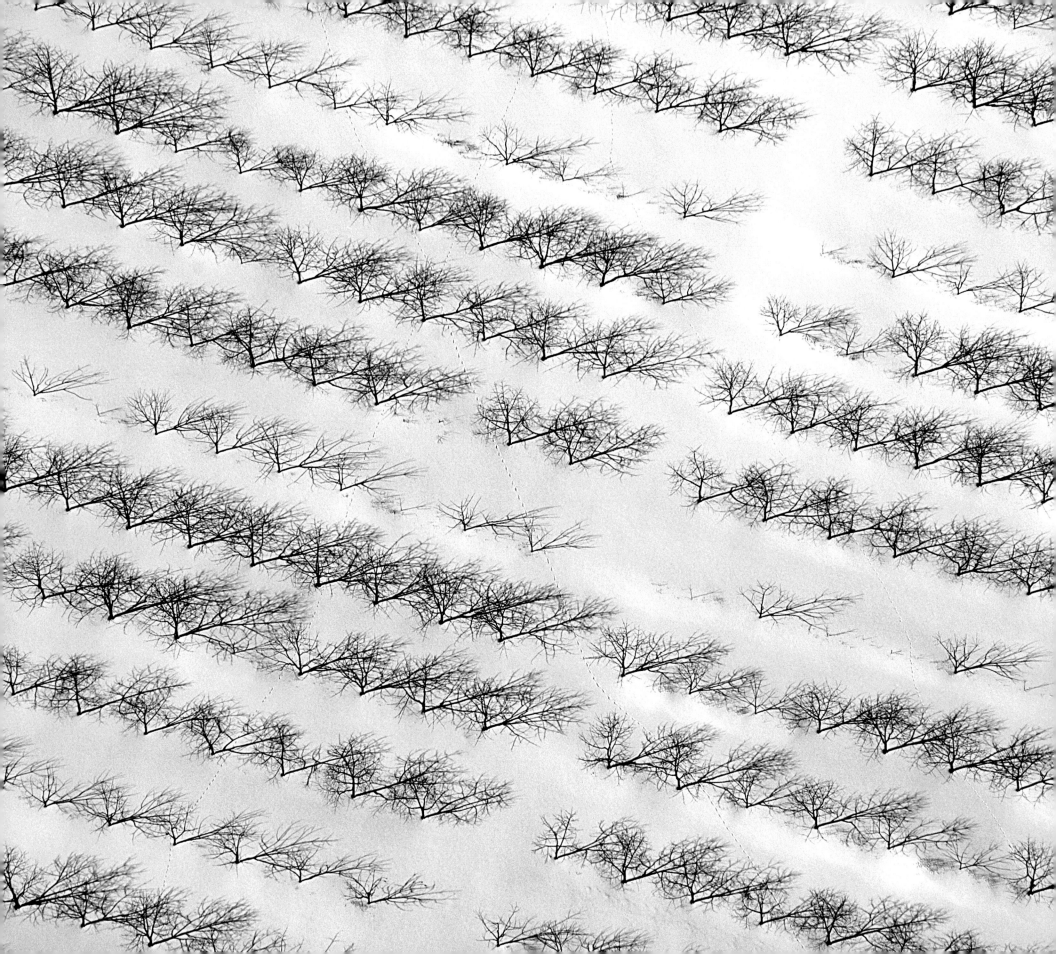

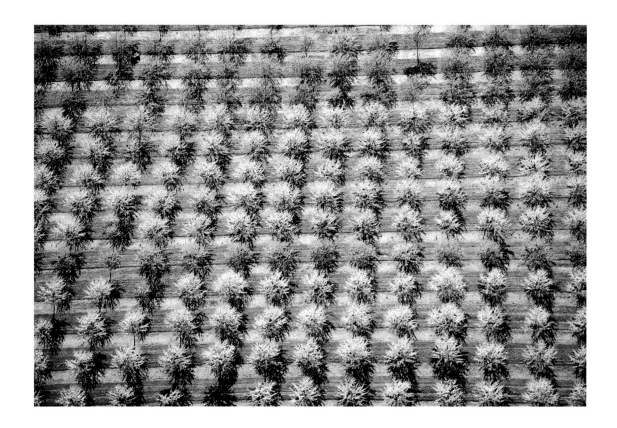

Orchard in spring

Orchard with snow

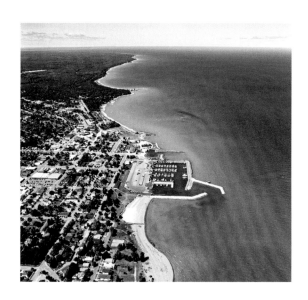

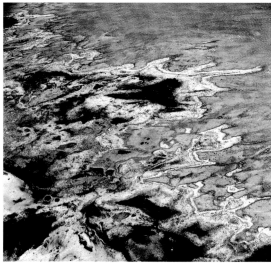

Rogers City Harbor

Sand shallows

Peninsula in Houghton Lake

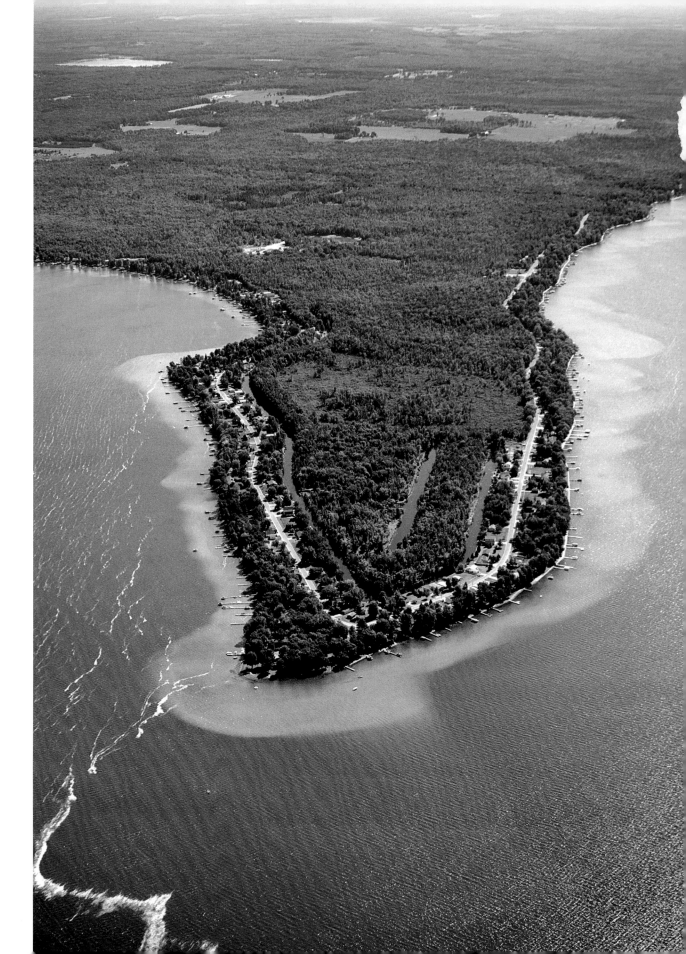

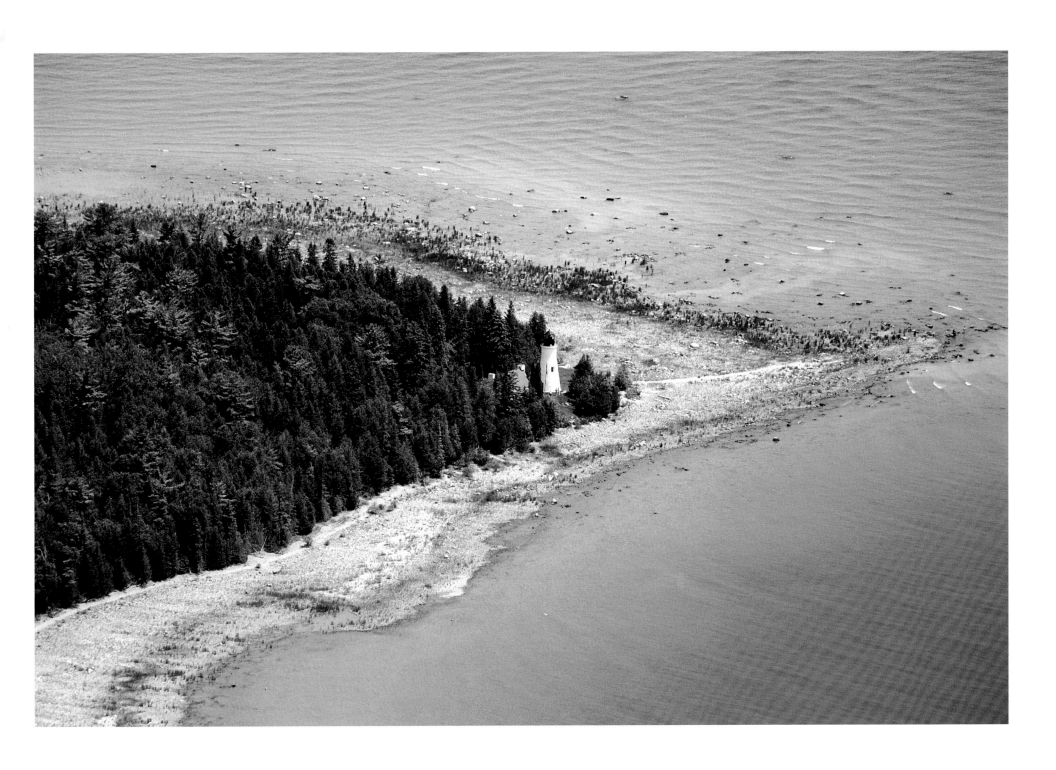

Old Presque Isle Lighthouse

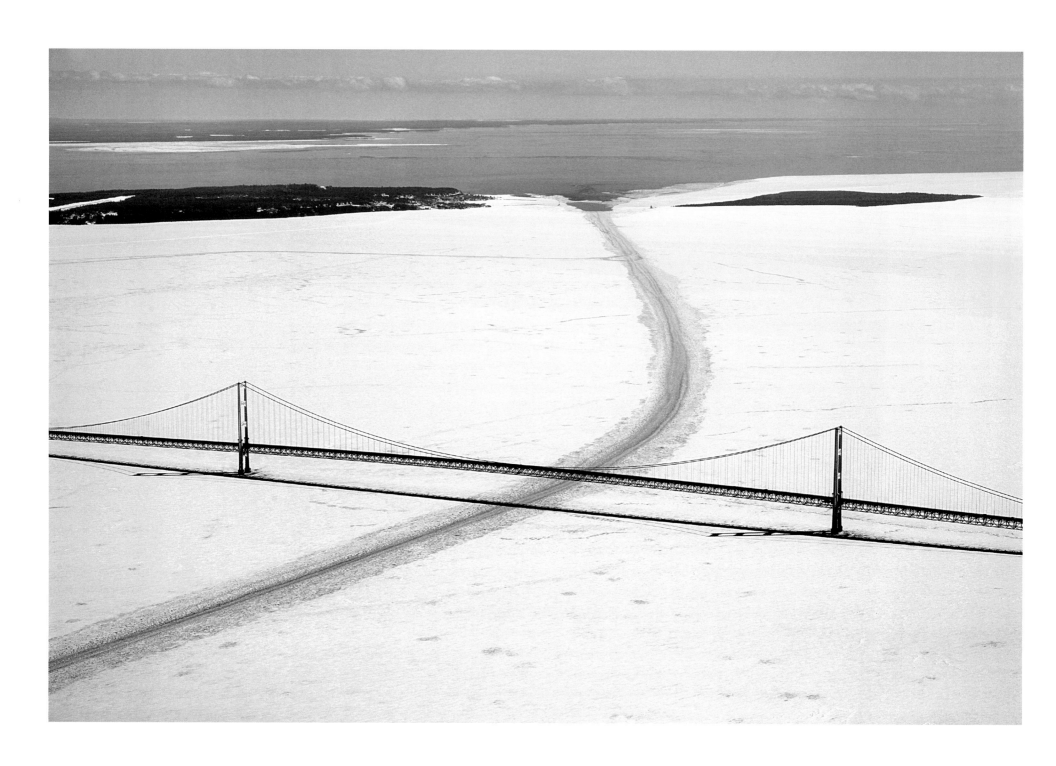

Mackinac Bridge

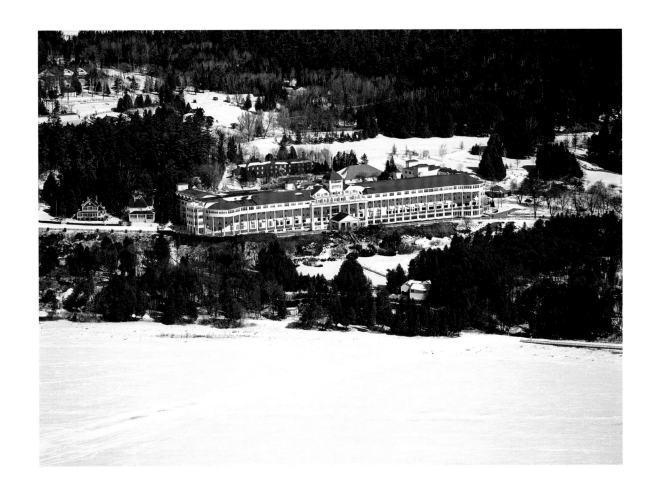

The Grand Hotel on Mackinac Island

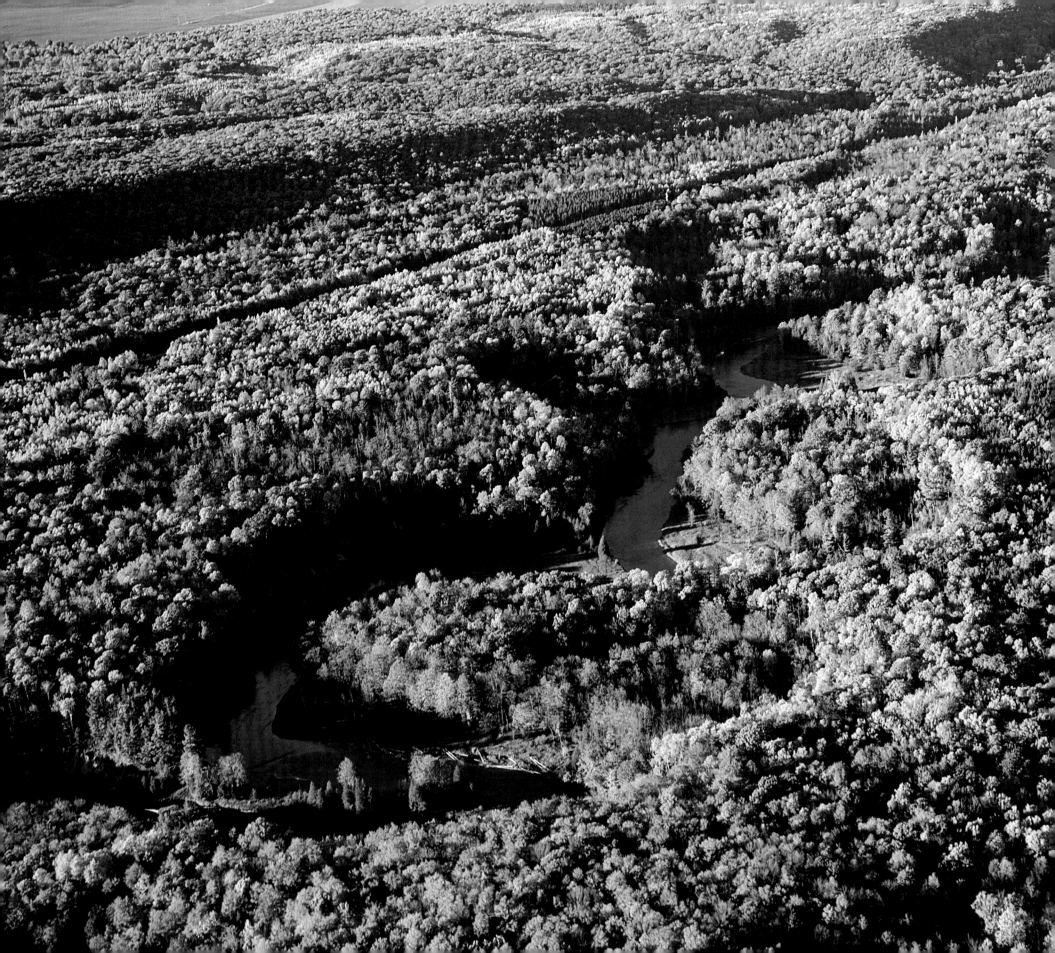

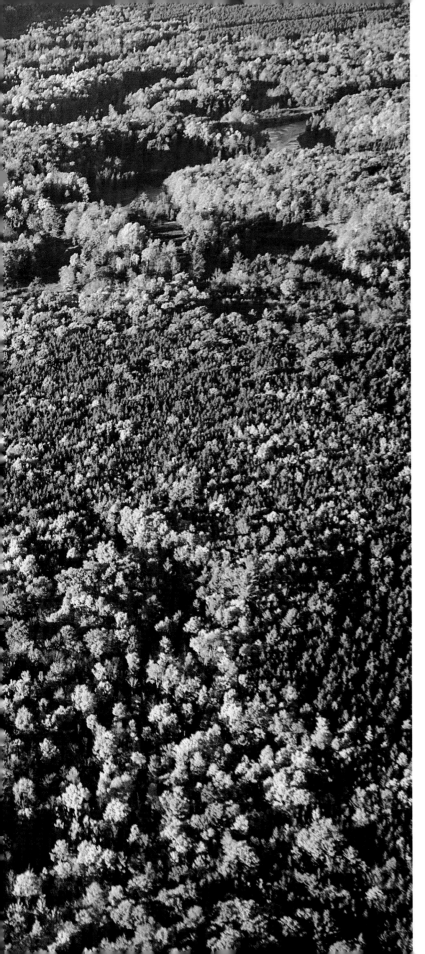

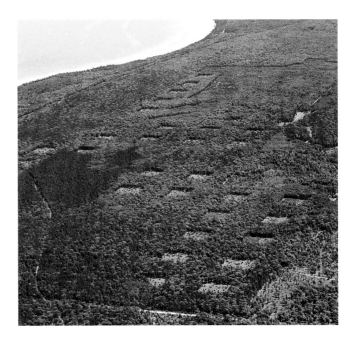

Clear cut squares

Fall color on Manistee River

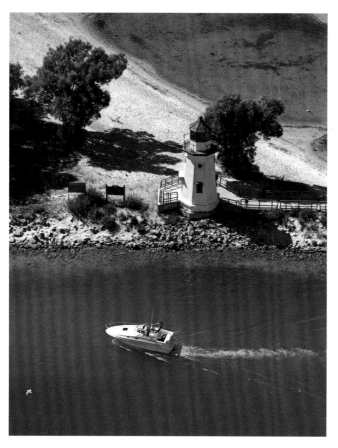

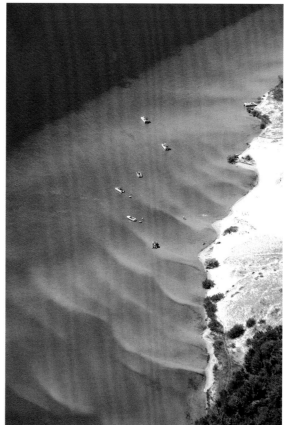

Cheboygan Lighthouse

Hamlin Lake sand & boats

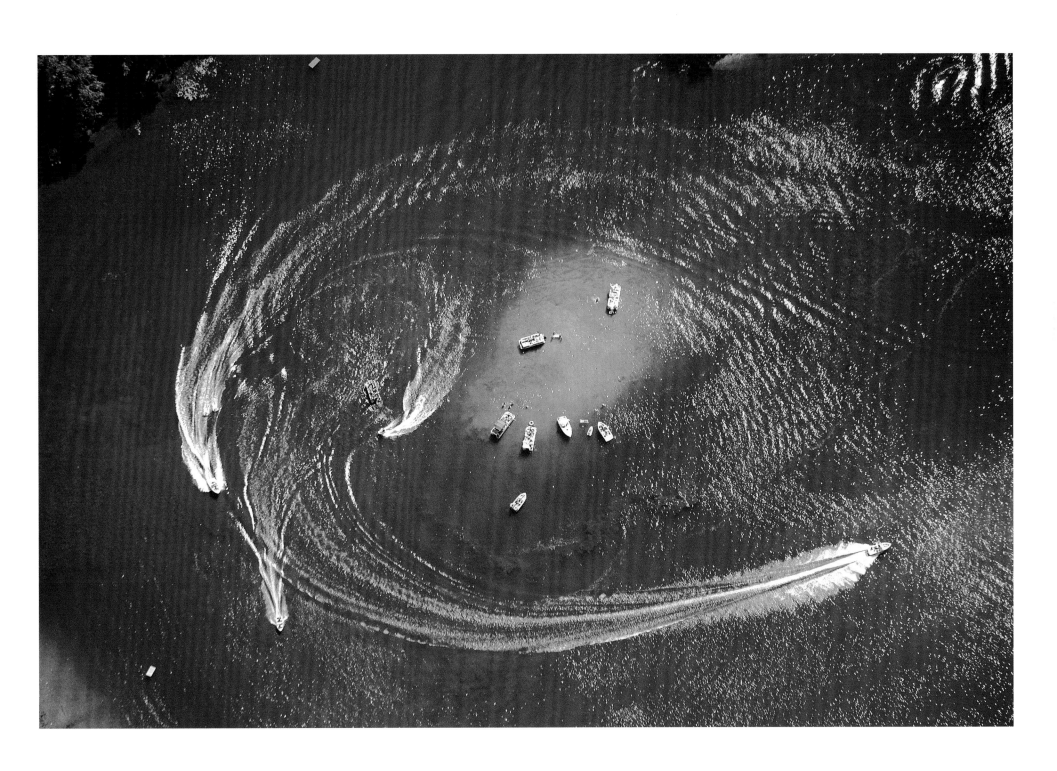

Boating fun

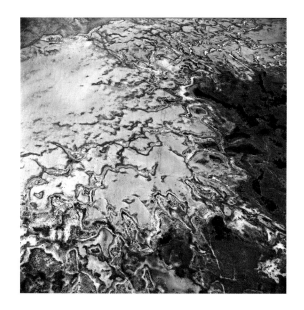

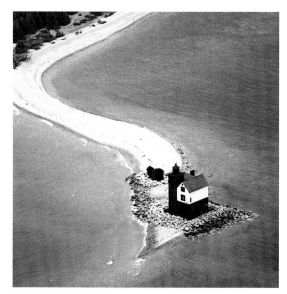

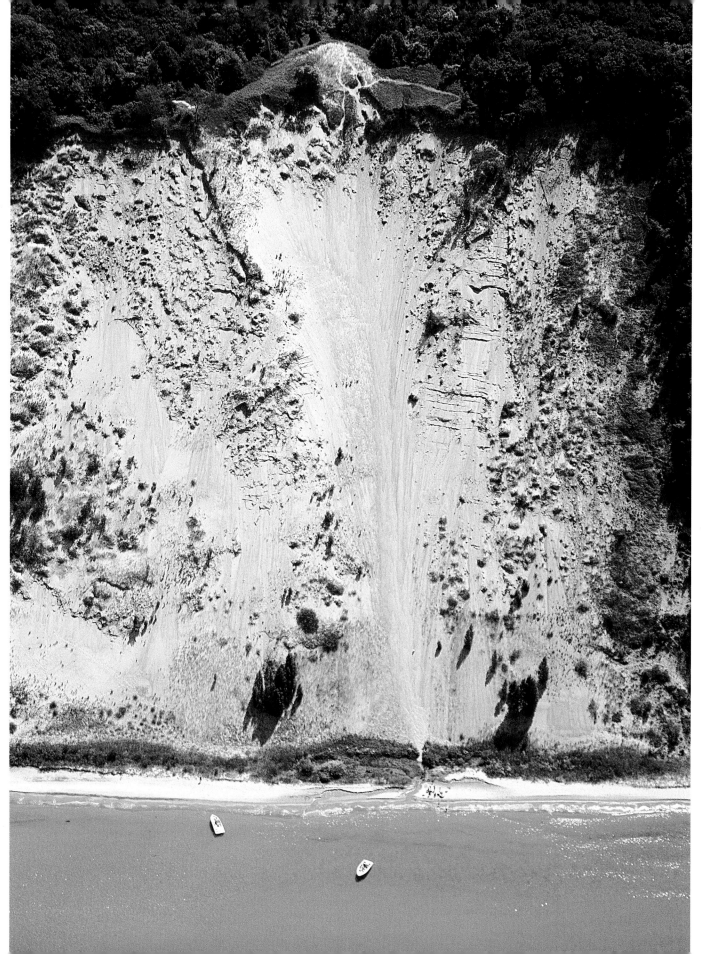

Wilderness State Park

Round Island Lighthouse

Sand dune

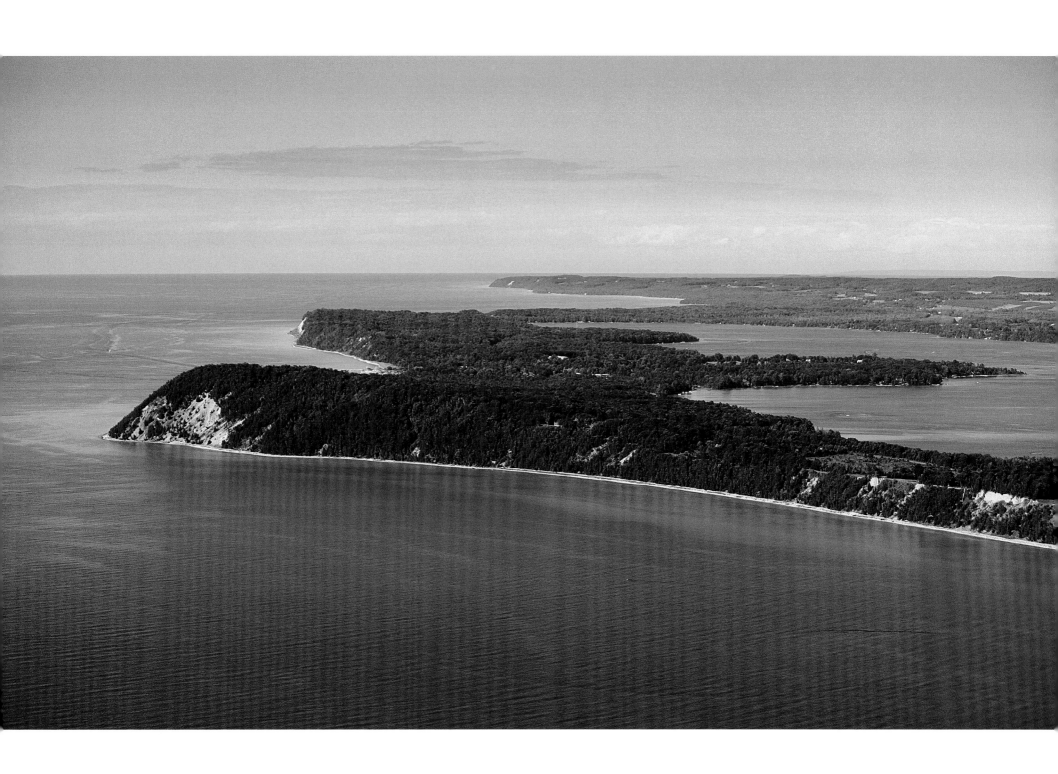

Shoreline south of Leland

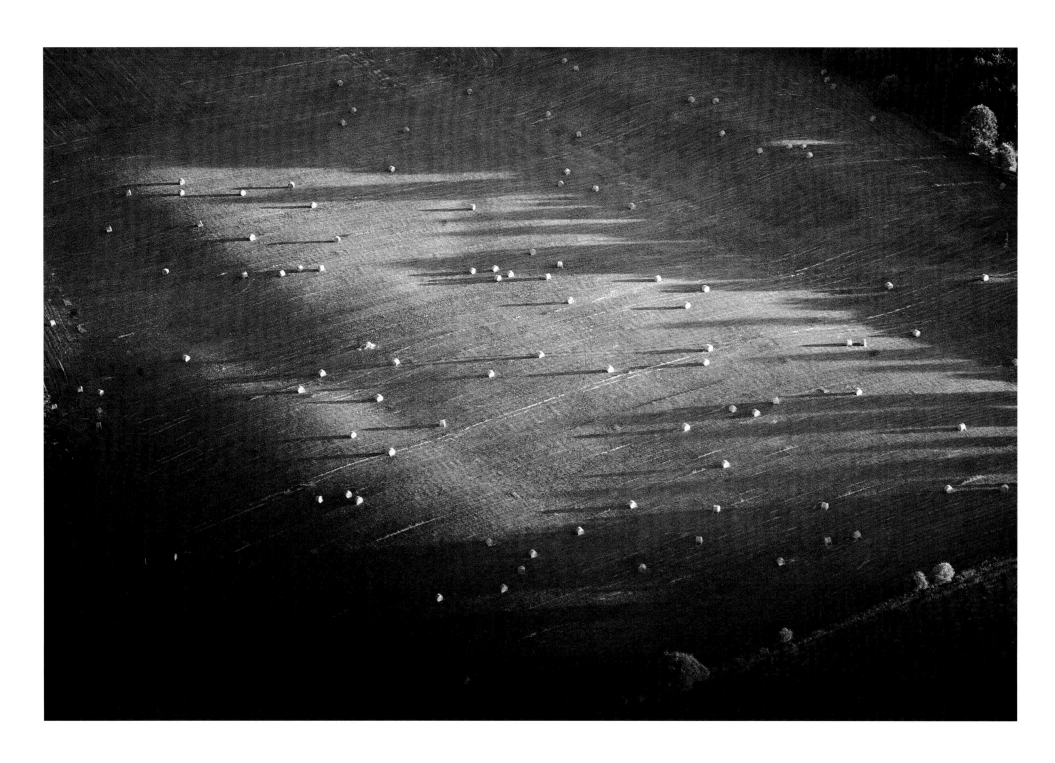

Hay bales

Harvest time

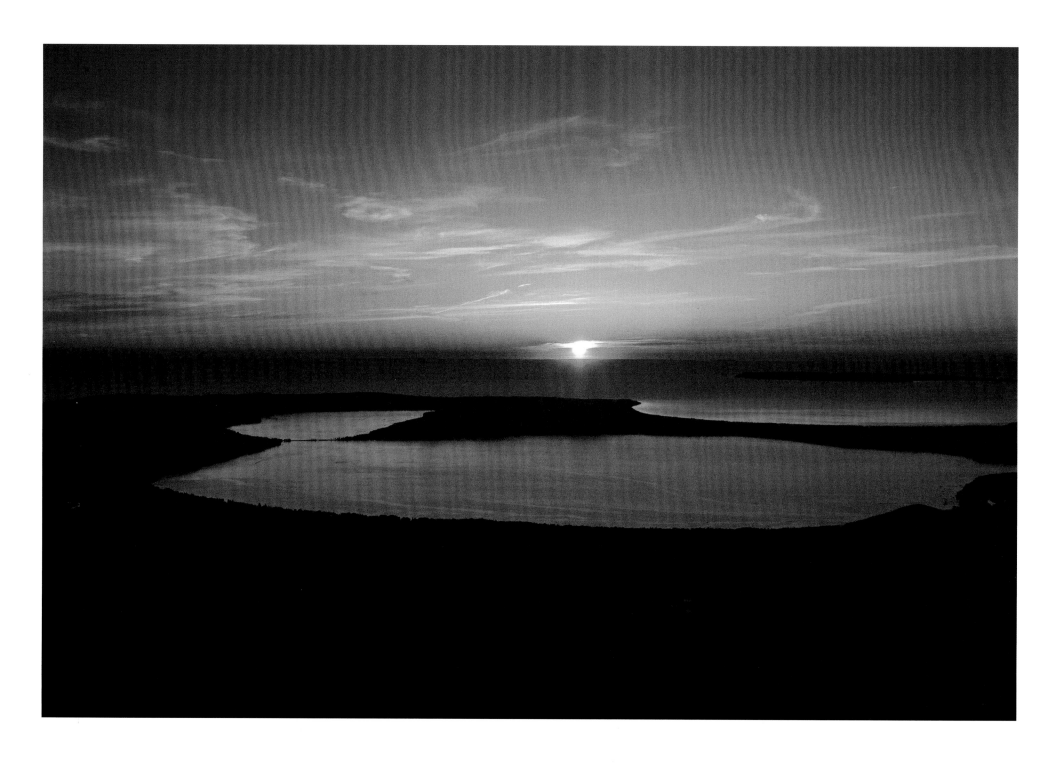

Glen Lake sunset

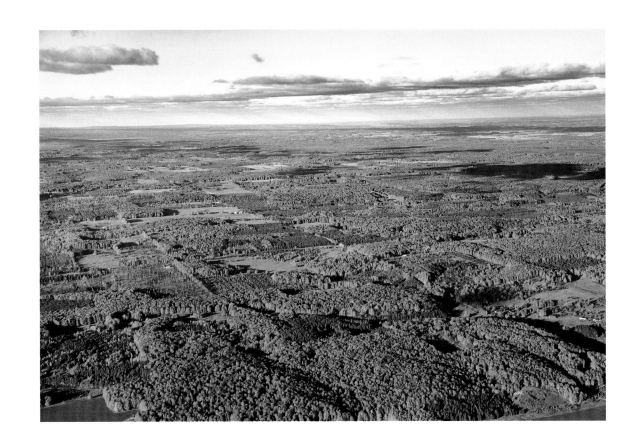

Fall color west of Cadillac

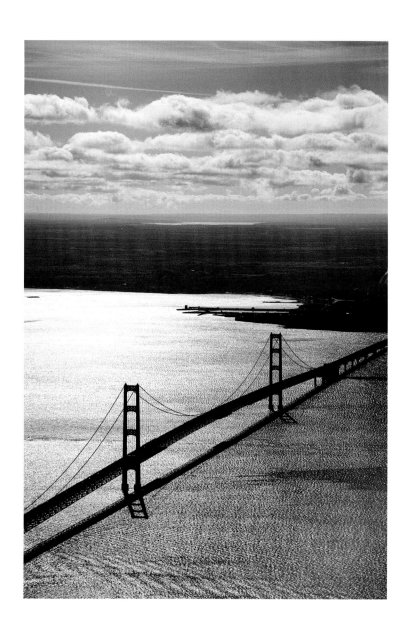

Mackinac Bridge

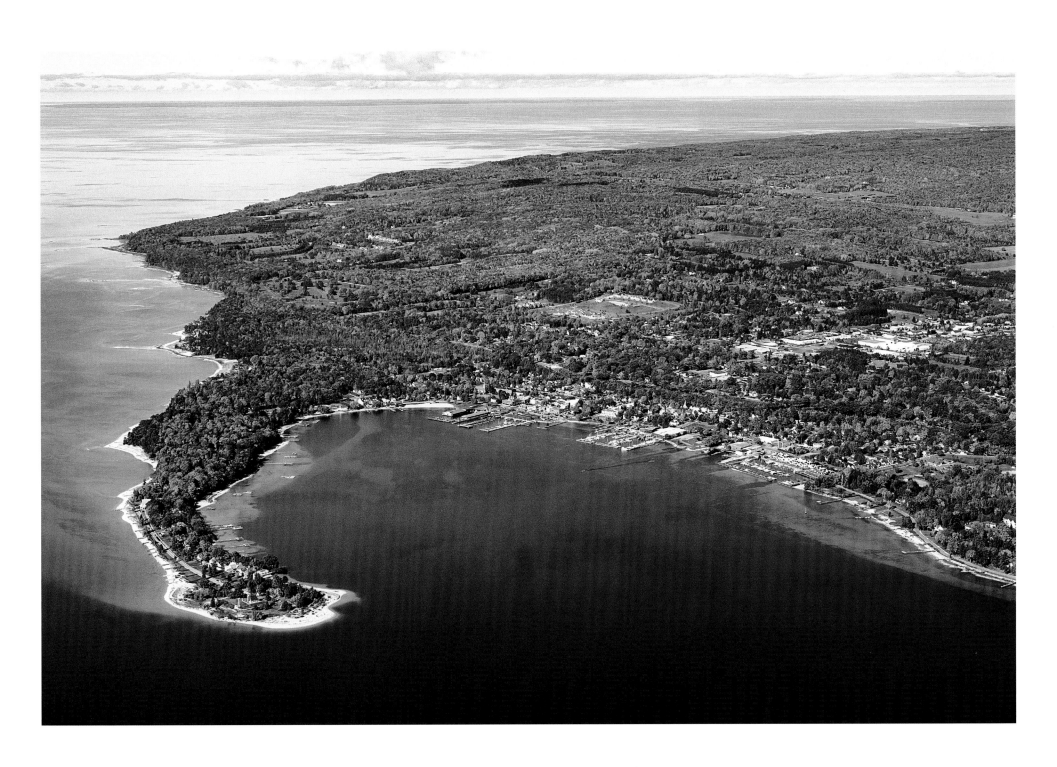

Harbor Springs in the fall

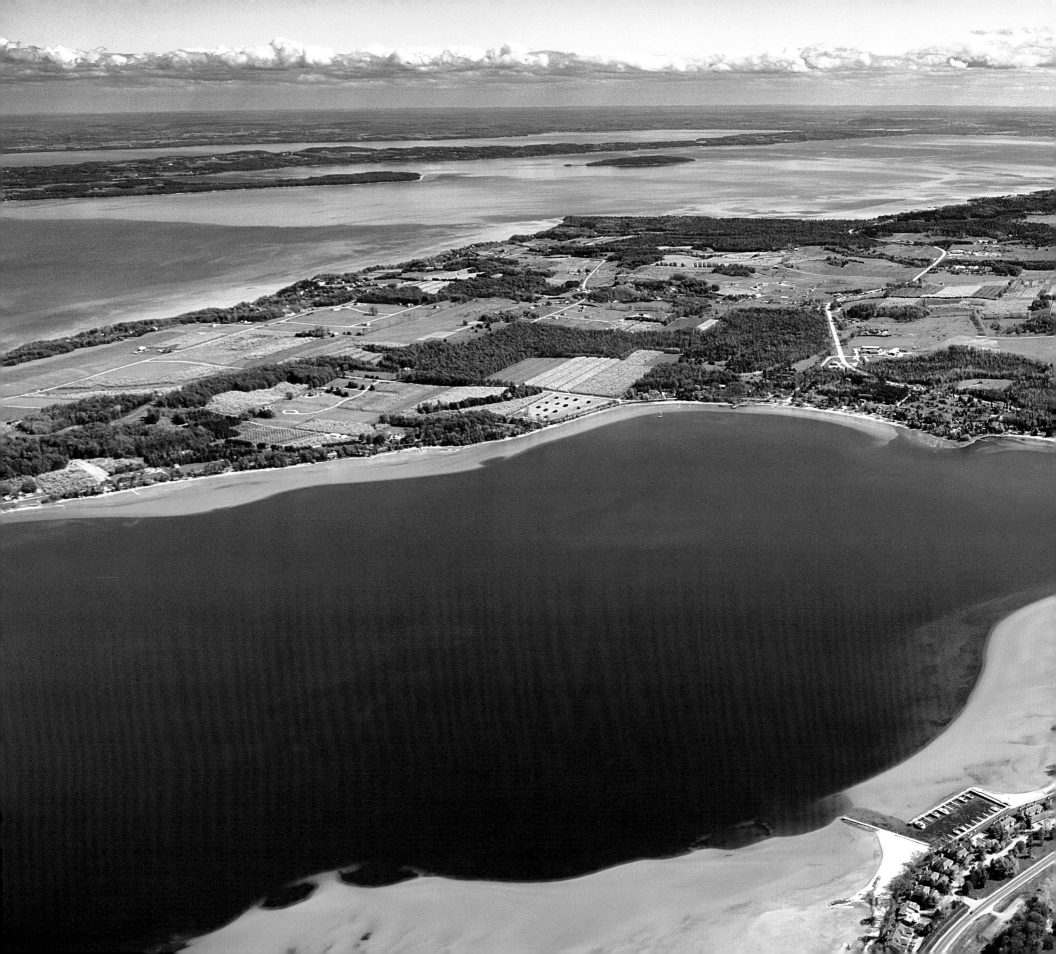

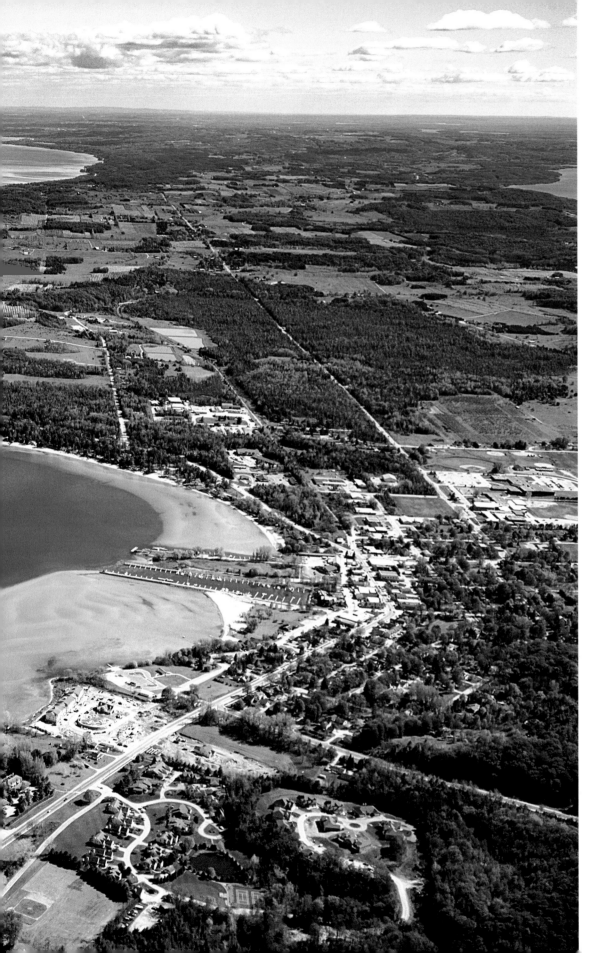

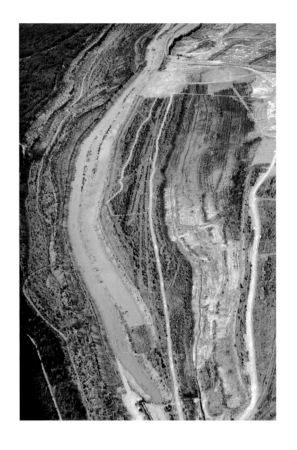

Quarry at Stoneport

Suttons Bay

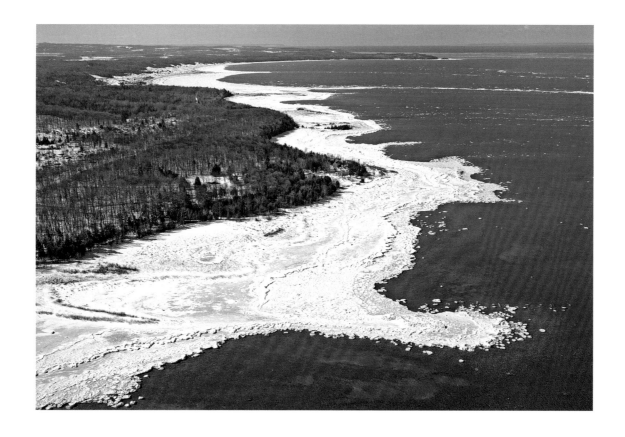

Grand Traverse Lighthouse

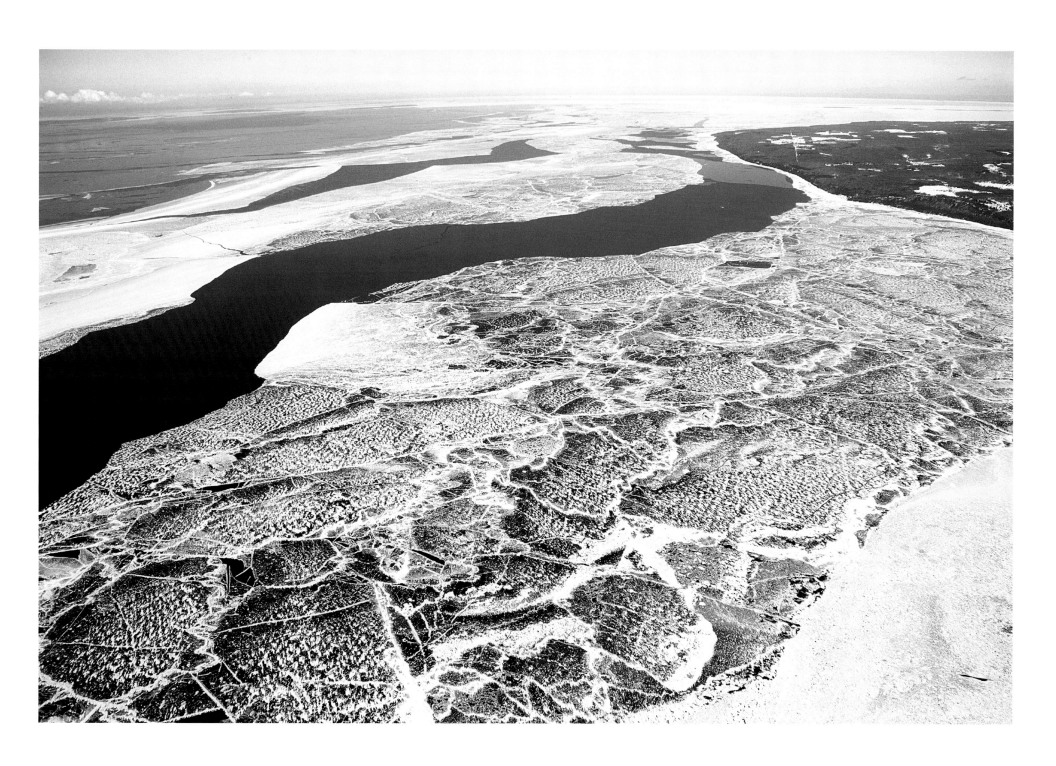

Ice flows in Lake Michigan

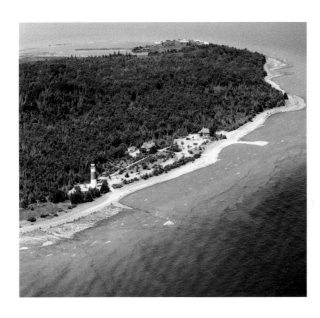

Middle Island Lighthouse

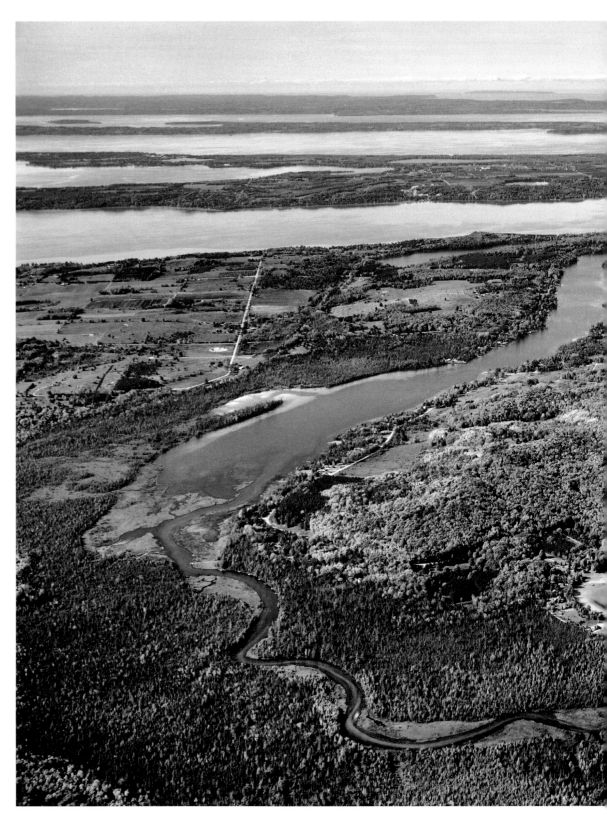

Clam Lake & Lake Bellaire

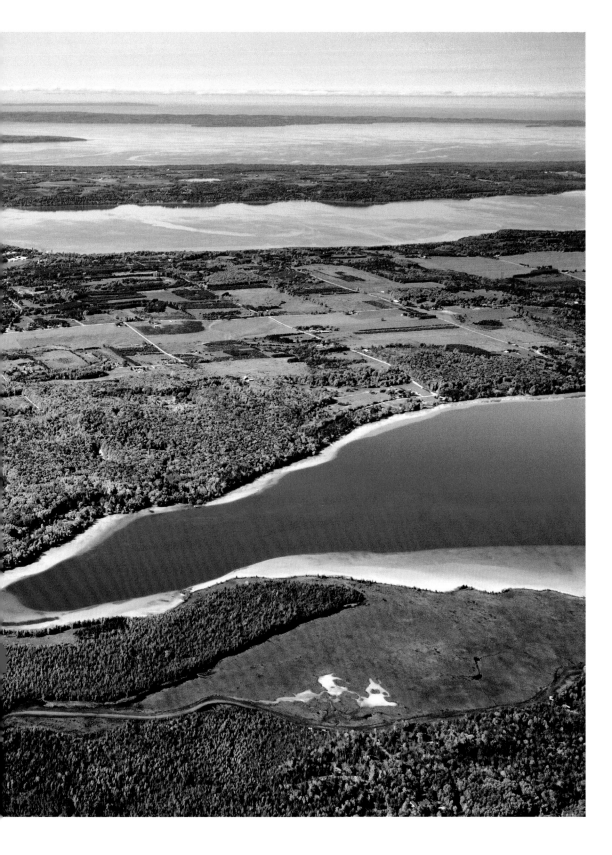

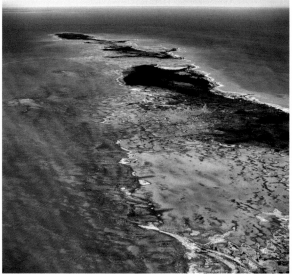

Wilderness State Park

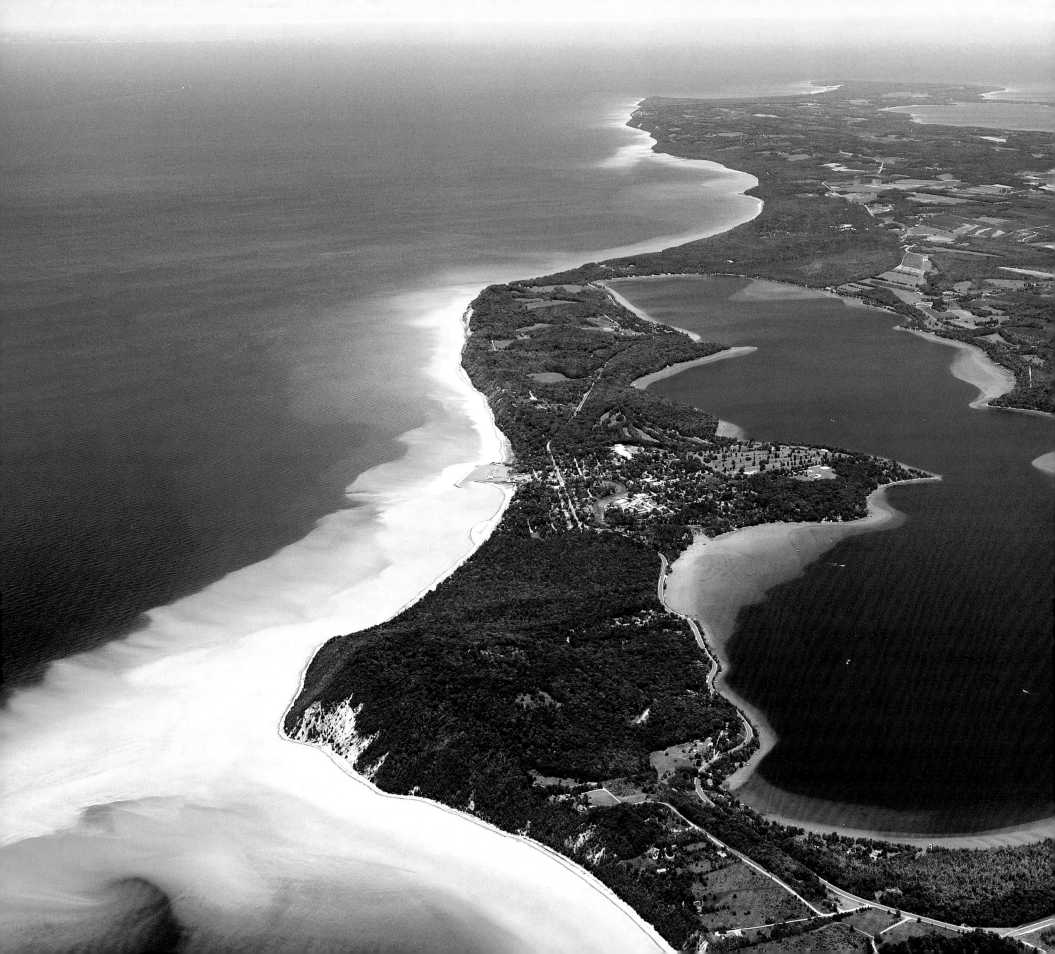

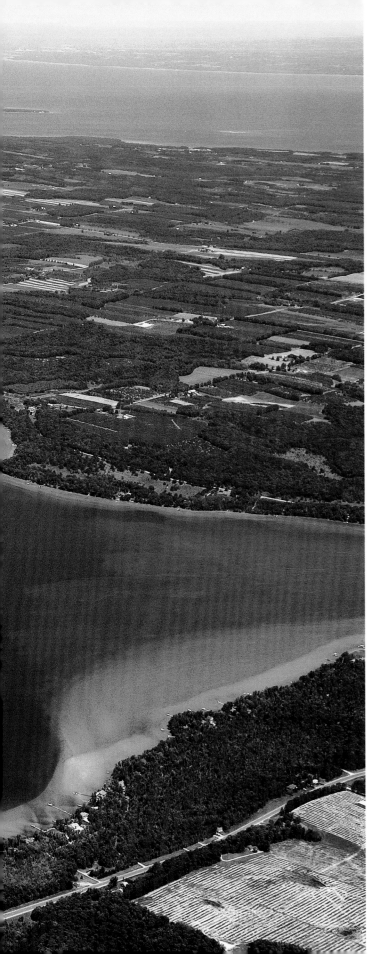

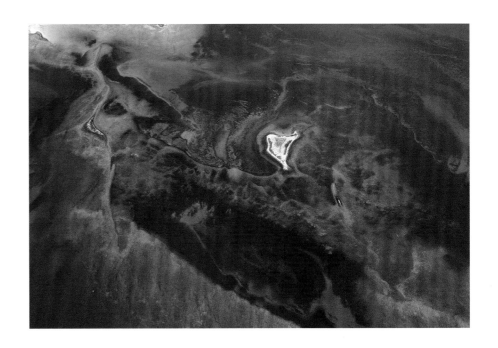

Garden Isle

Lake Leelanau

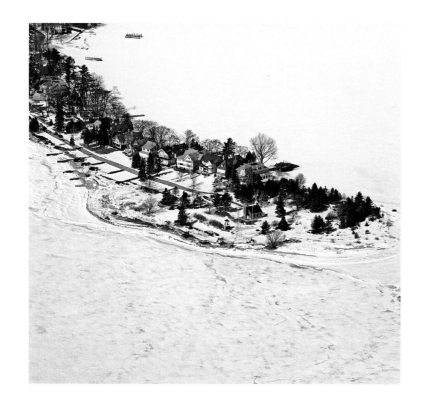

Little Traverse Lighthouse

Sleeping Bear Dunes in the winter

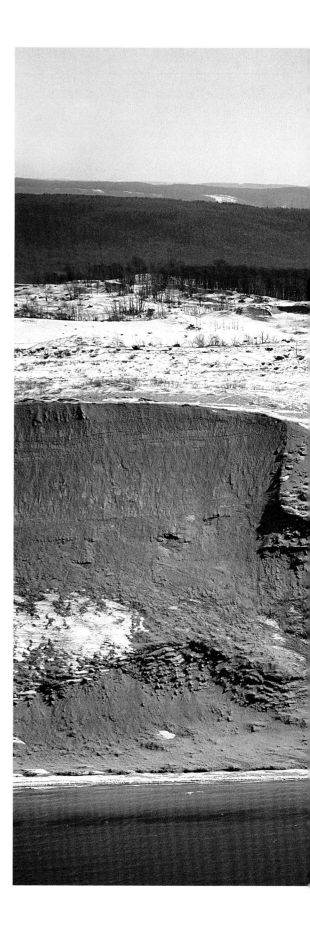

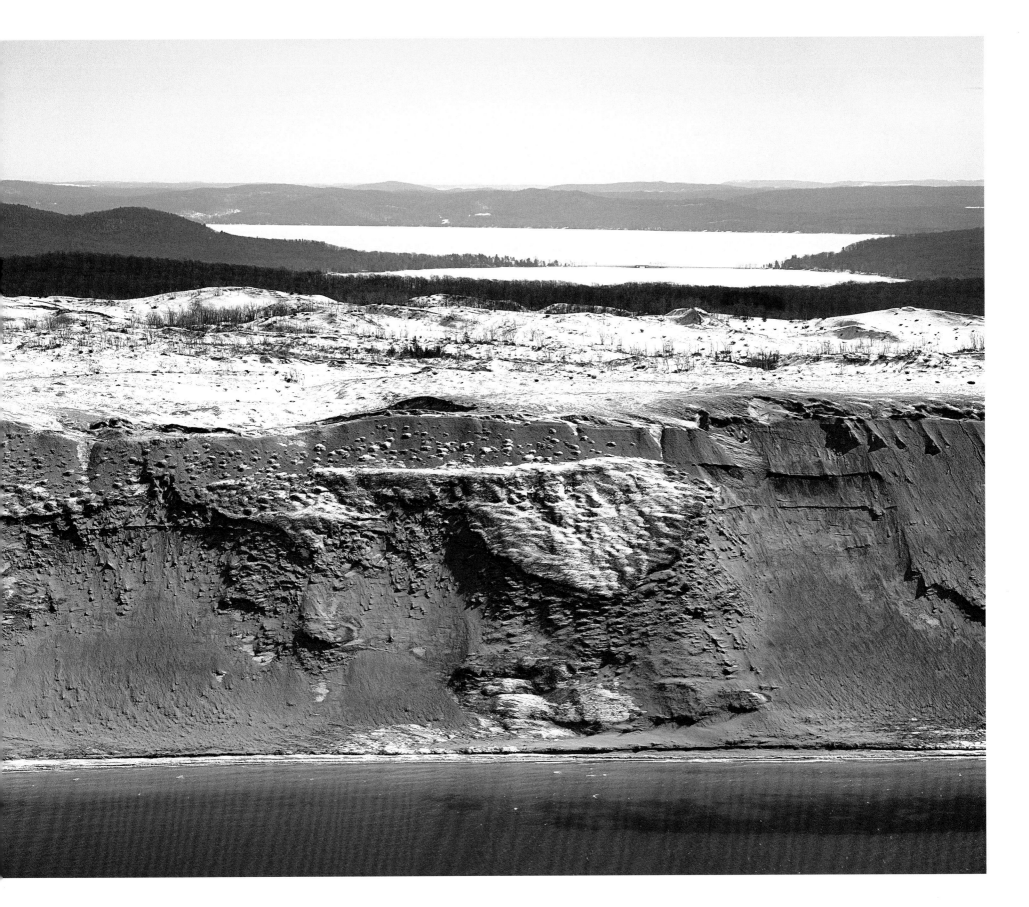

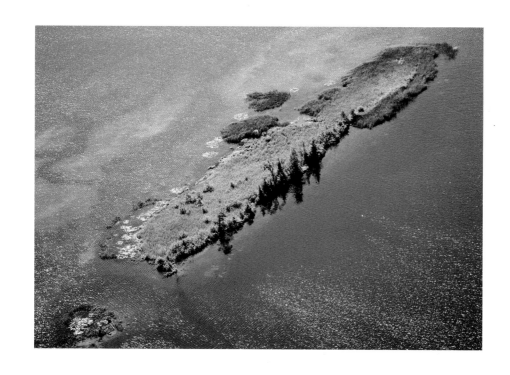

Island in the Au Sable River

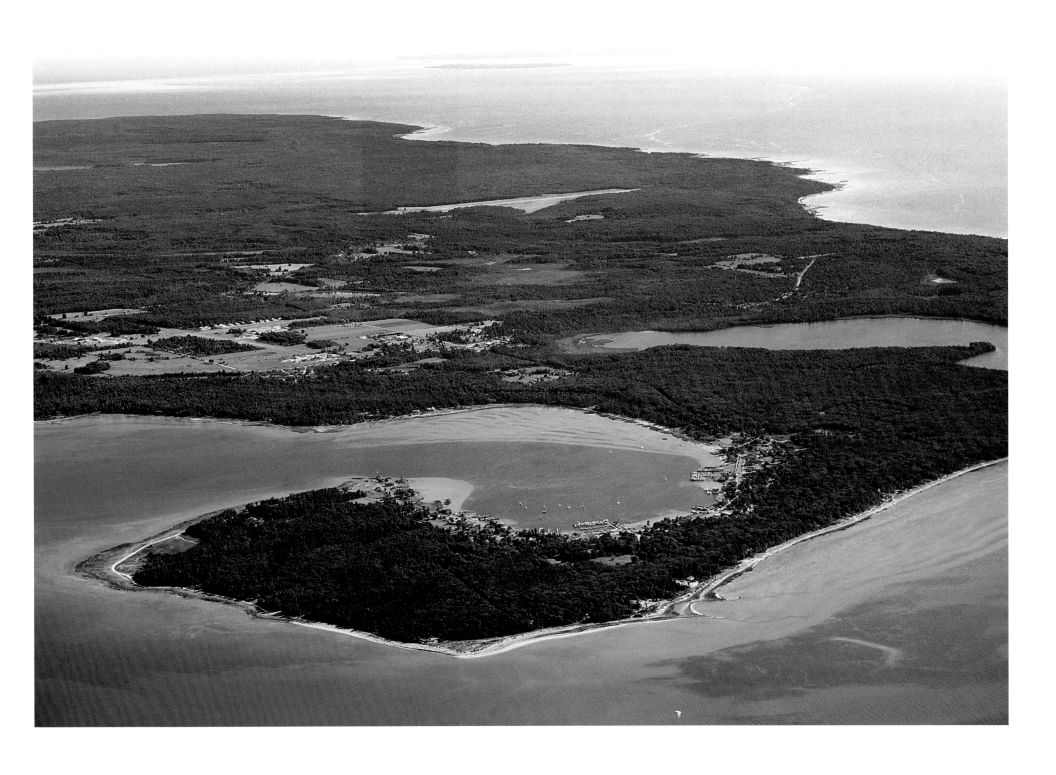

Beaver Island

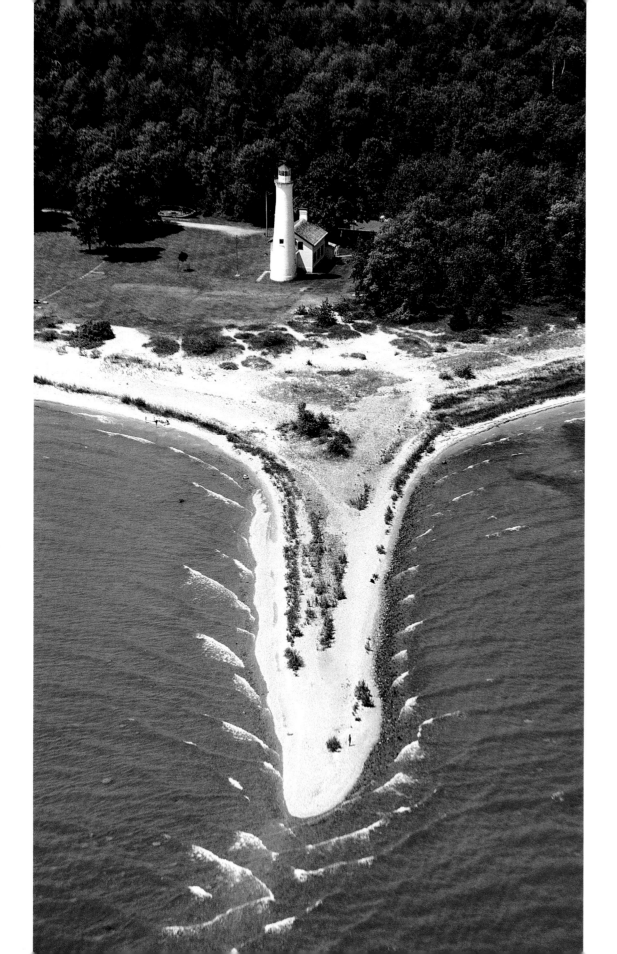

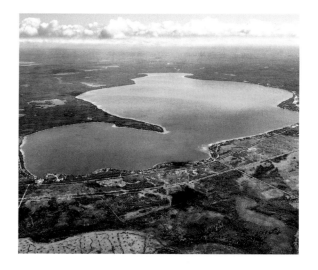

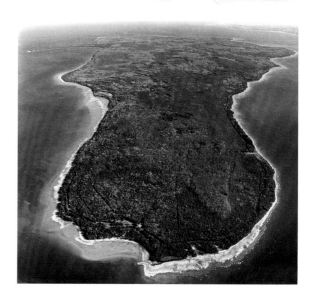

Houghton Lake

Bois Blanc Island

Sturgeon Point Lighthouse

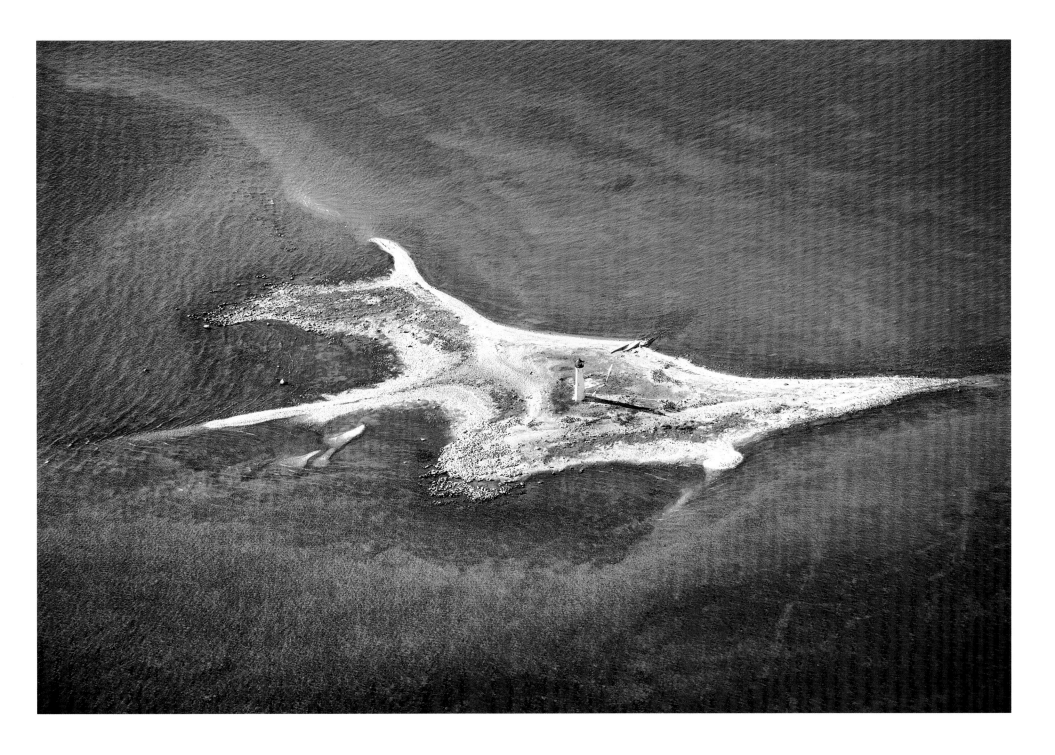

Ile Aux Galets

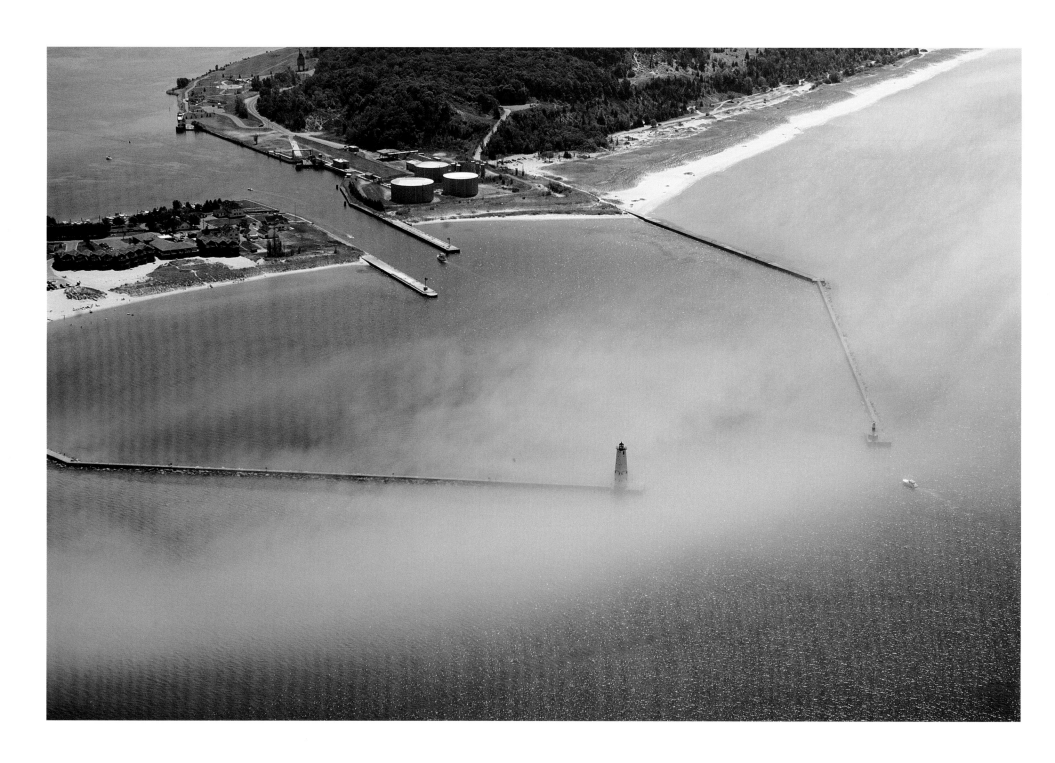

Frankfort Harbor in fog

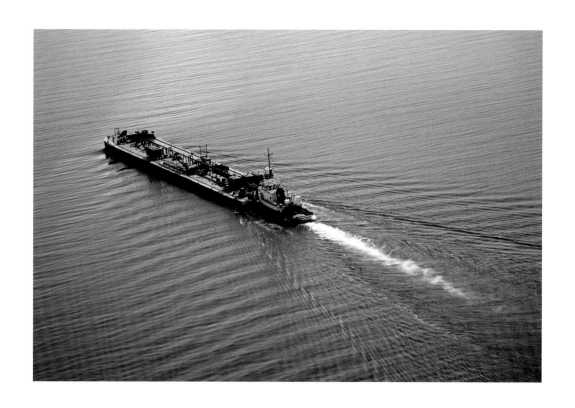

Oil barge in Grand Traverse Bay

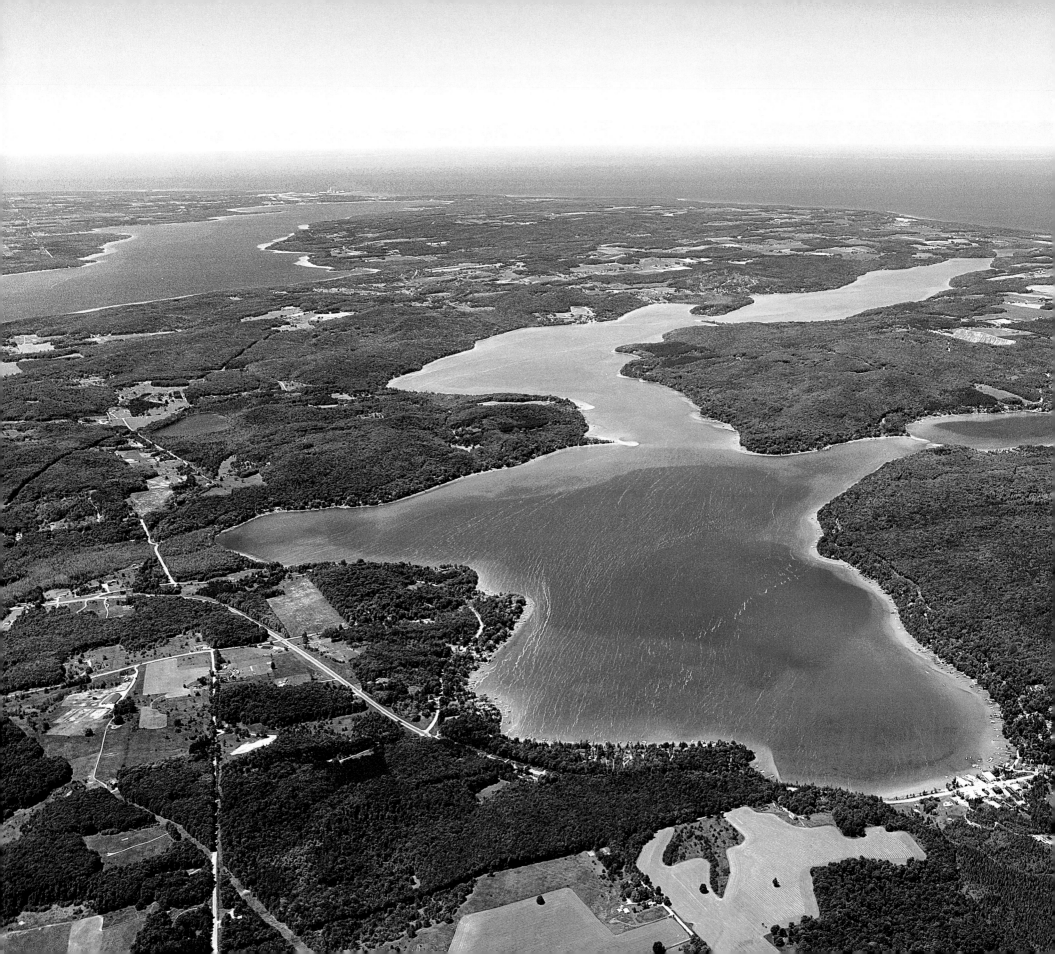

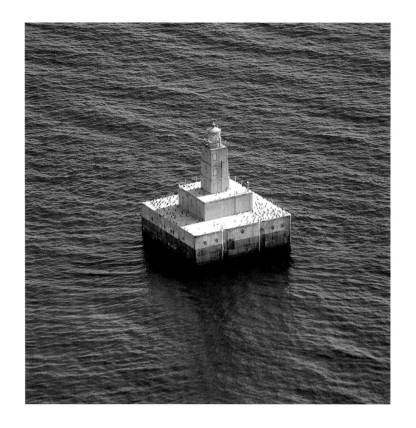

Lansing Shoal Lighthouse

Walloon Lake

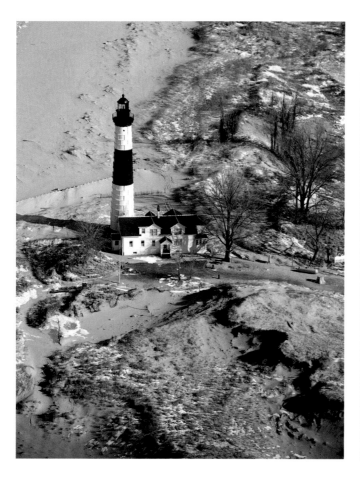

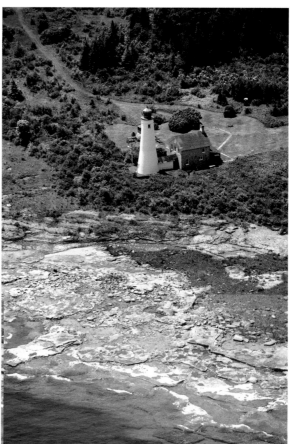

Big Sable Lighthouse

Thunder Bay Island Lighthouse

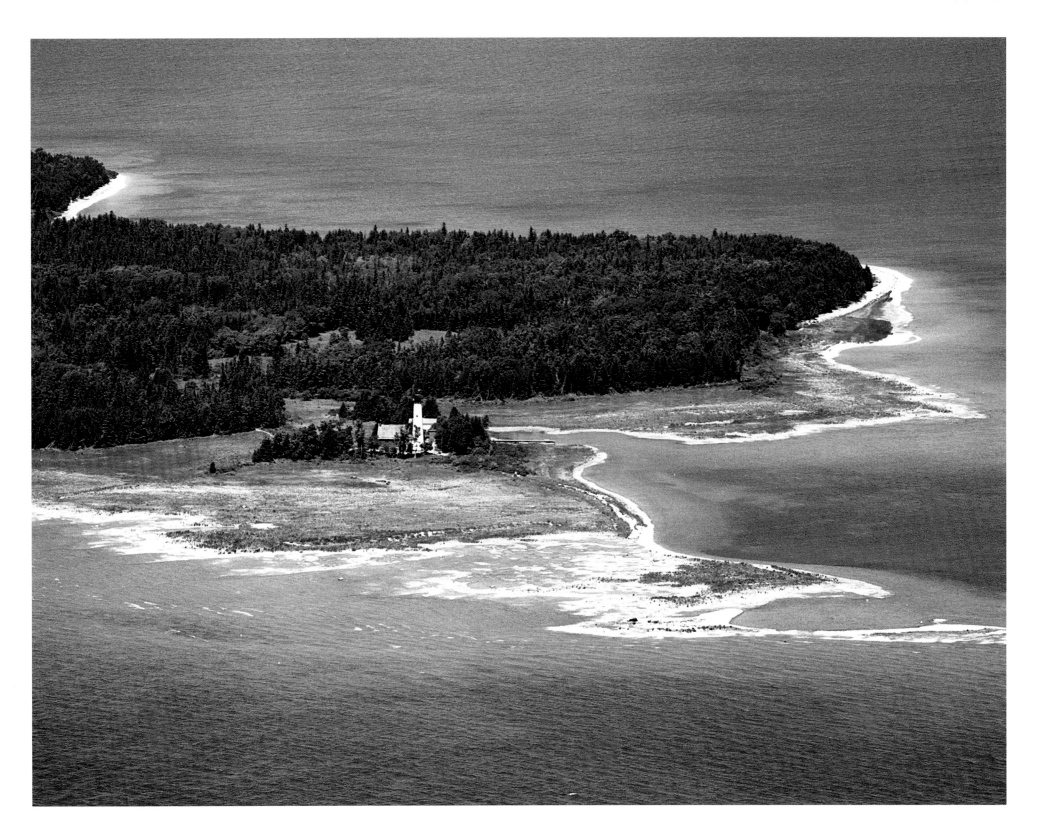

St. Helena Island

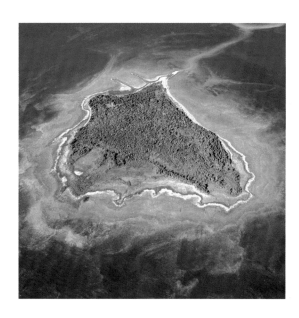

Squaw Island

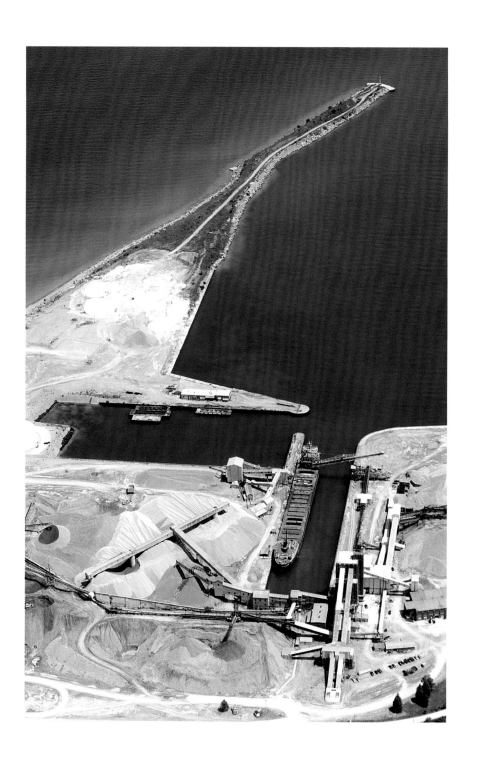

Rogers City

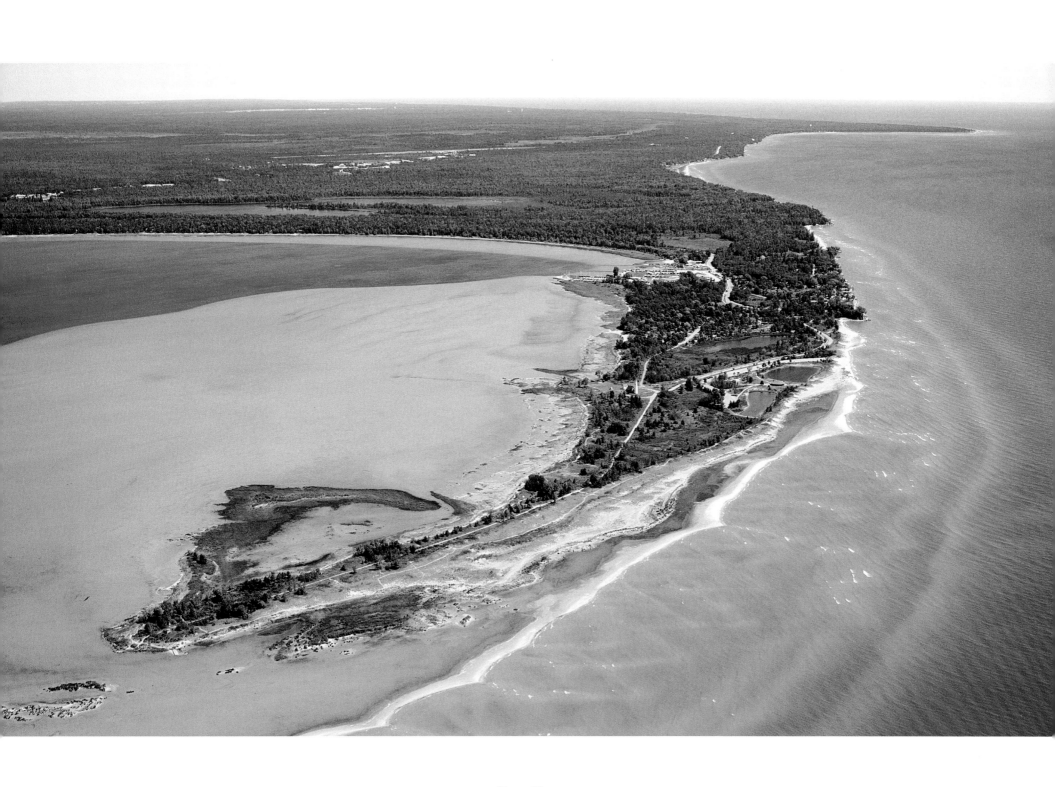

Tawas Point

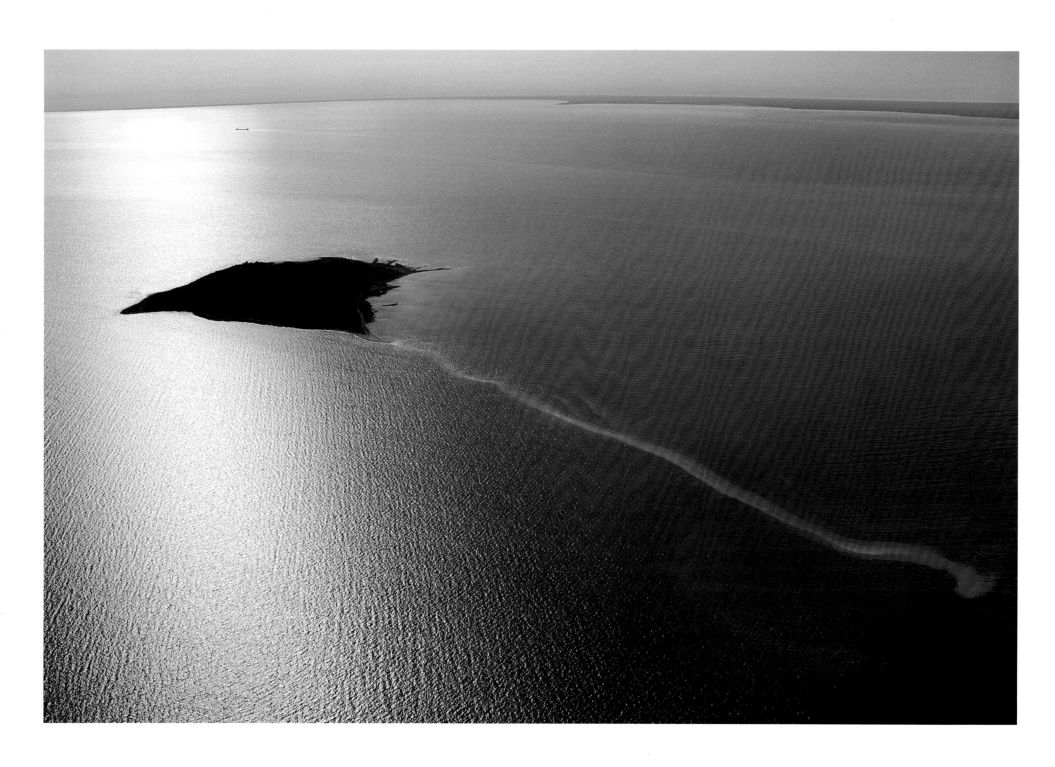

Whiskey Island

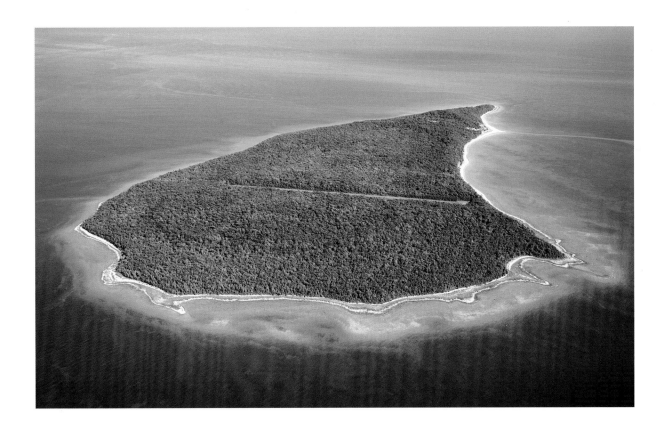

North Fox Island

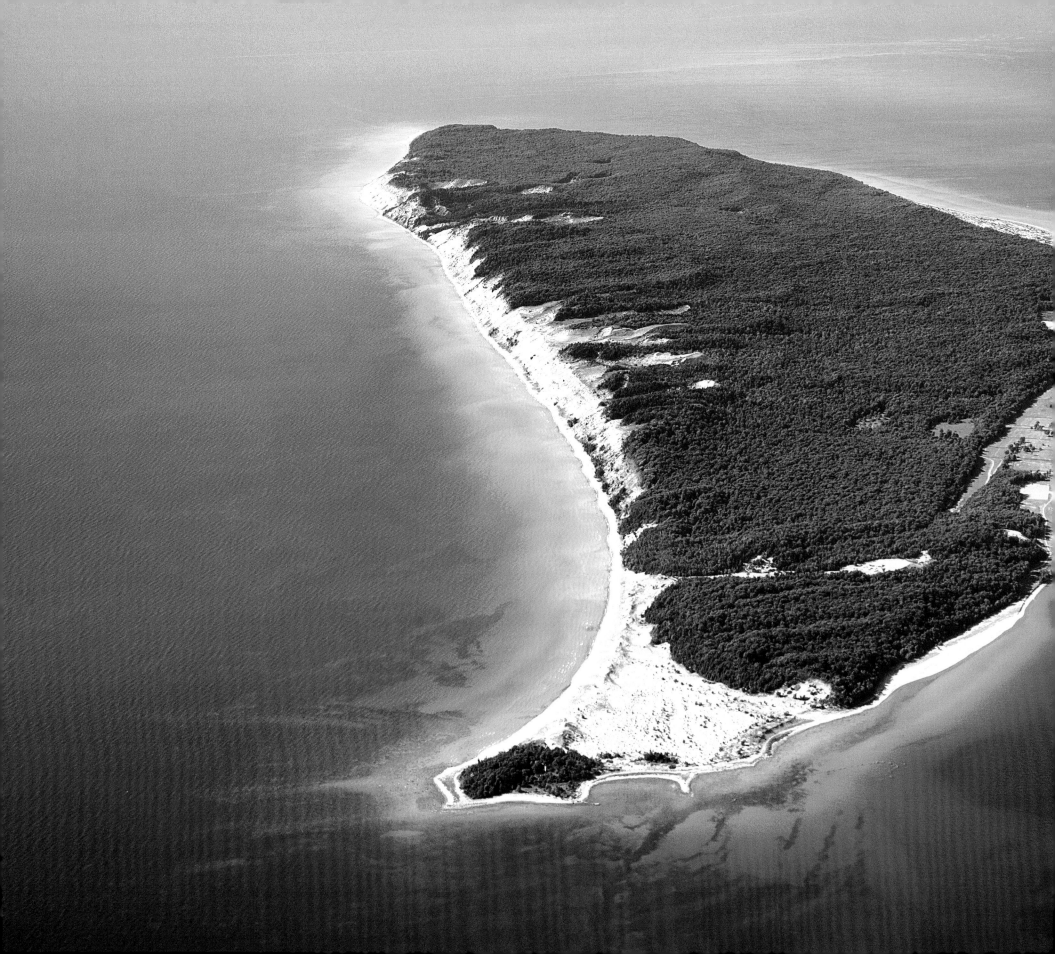

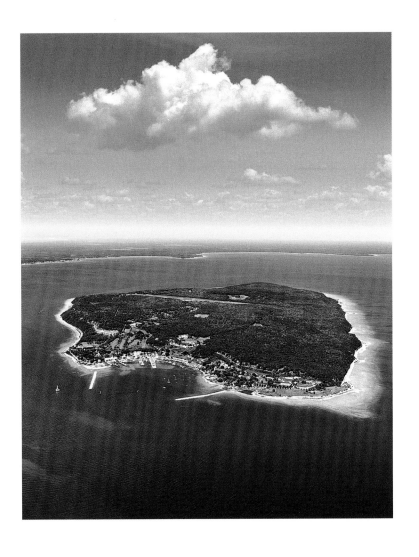

Mackinac Island

South Fox Island

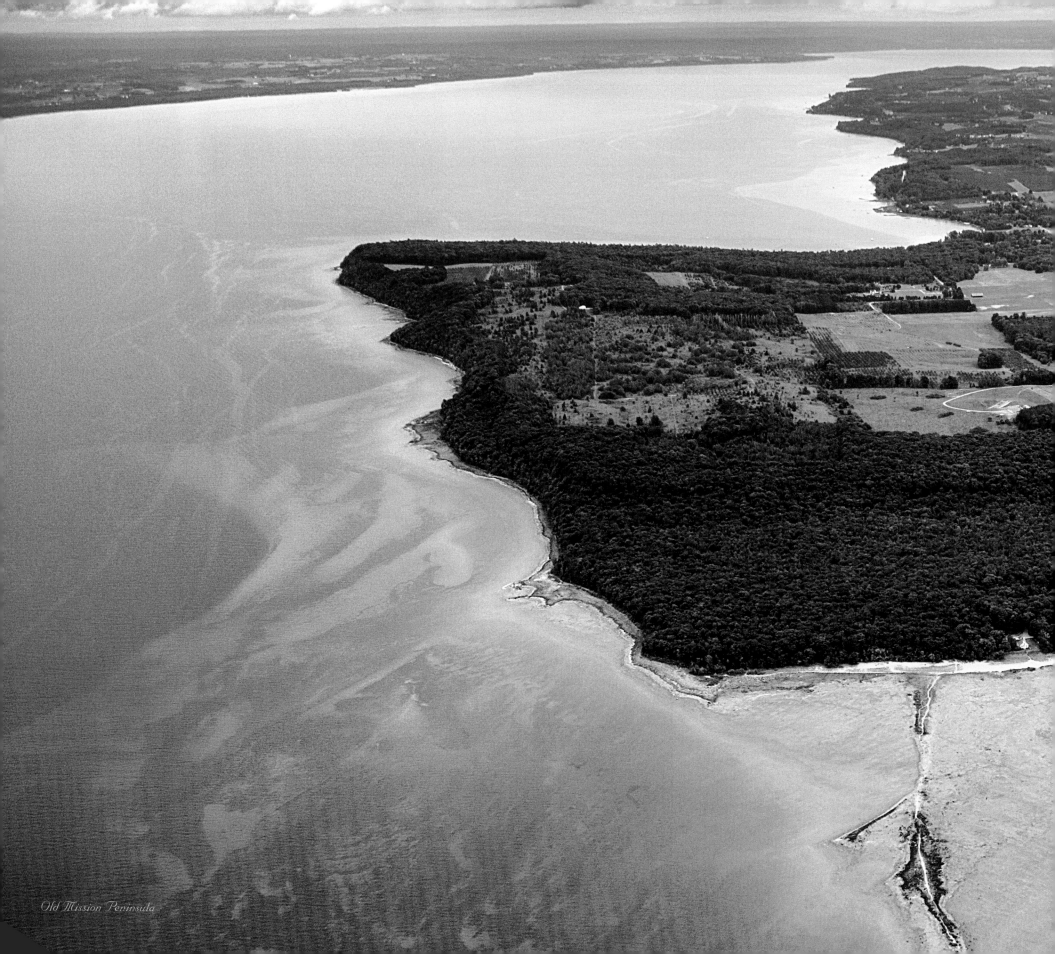

Old Mission Peninsula

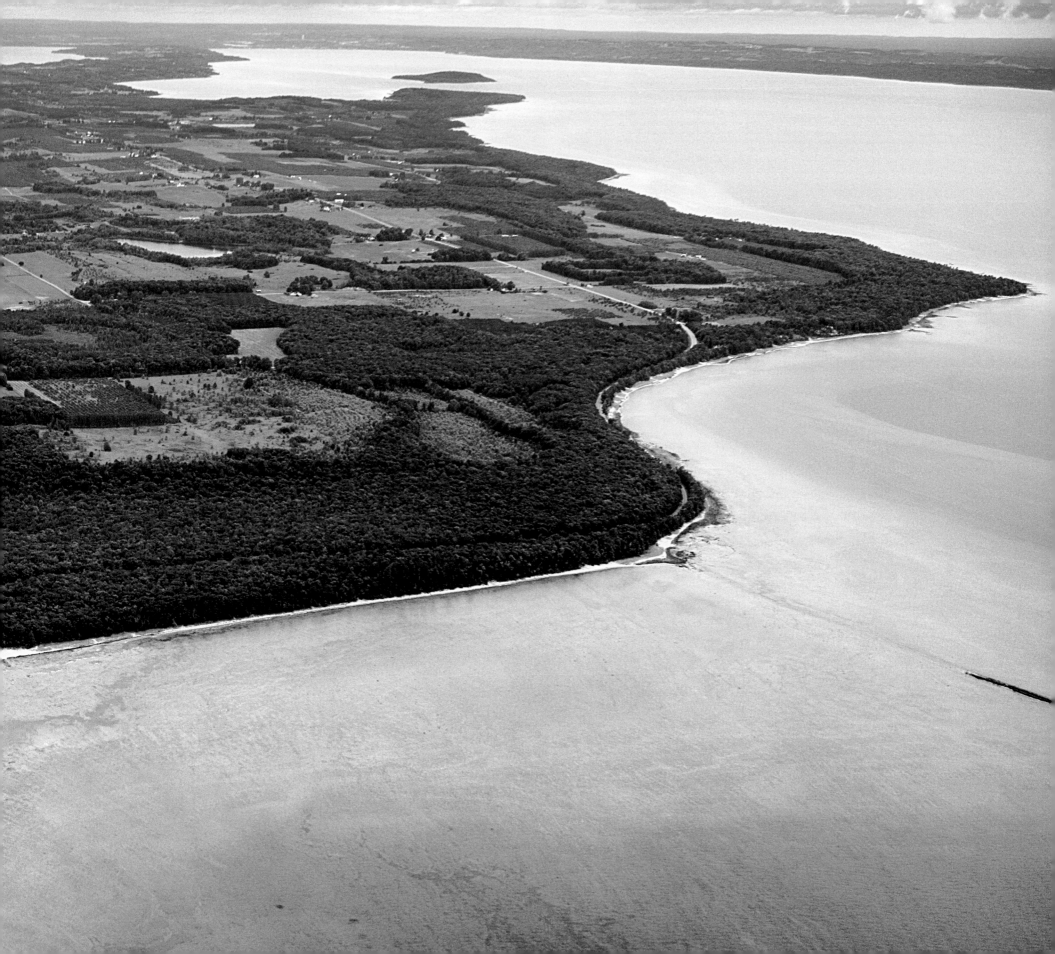

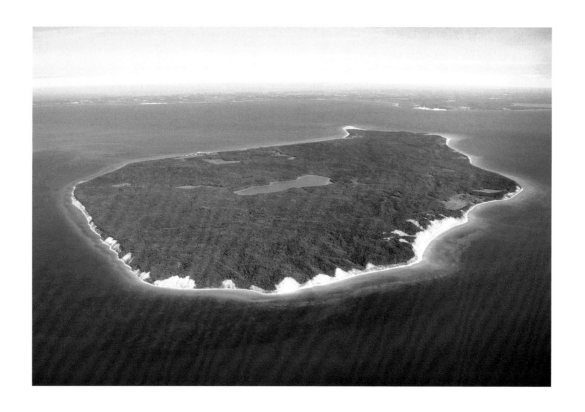

North Manitou Island

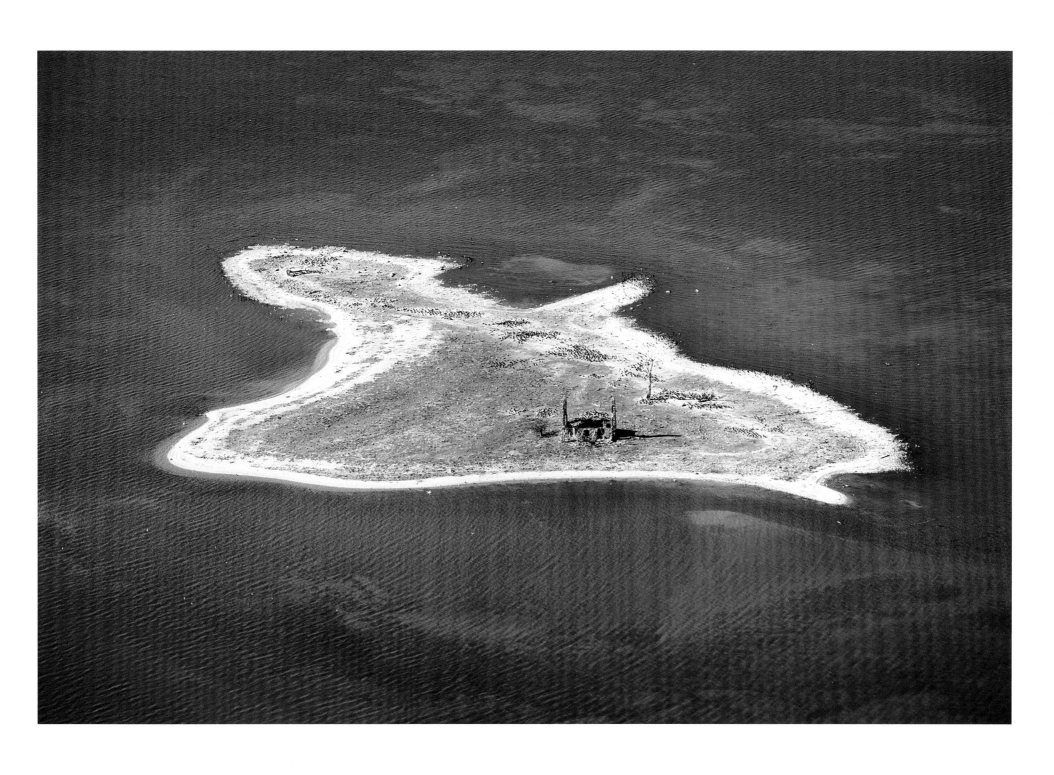

Gull Island

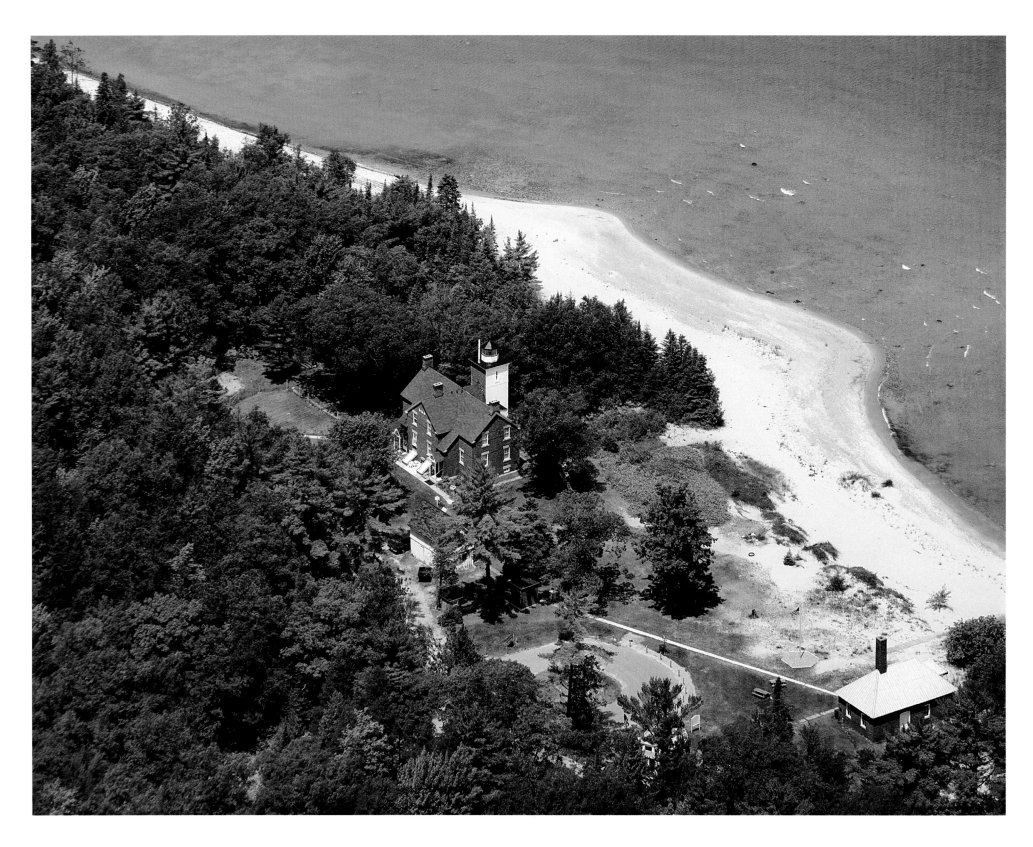

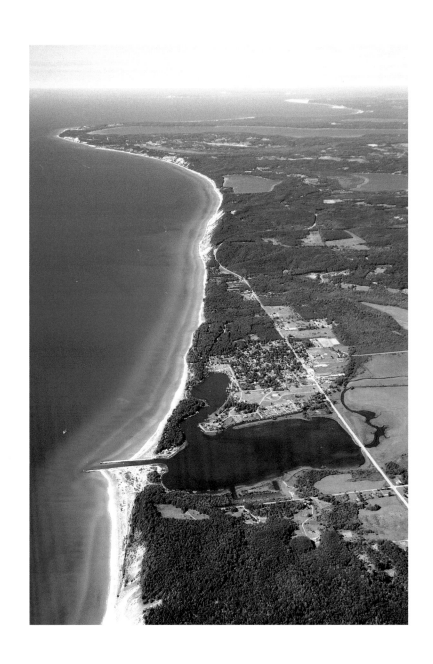

Arcadia shoreline

40 Mile Point Lighthouse

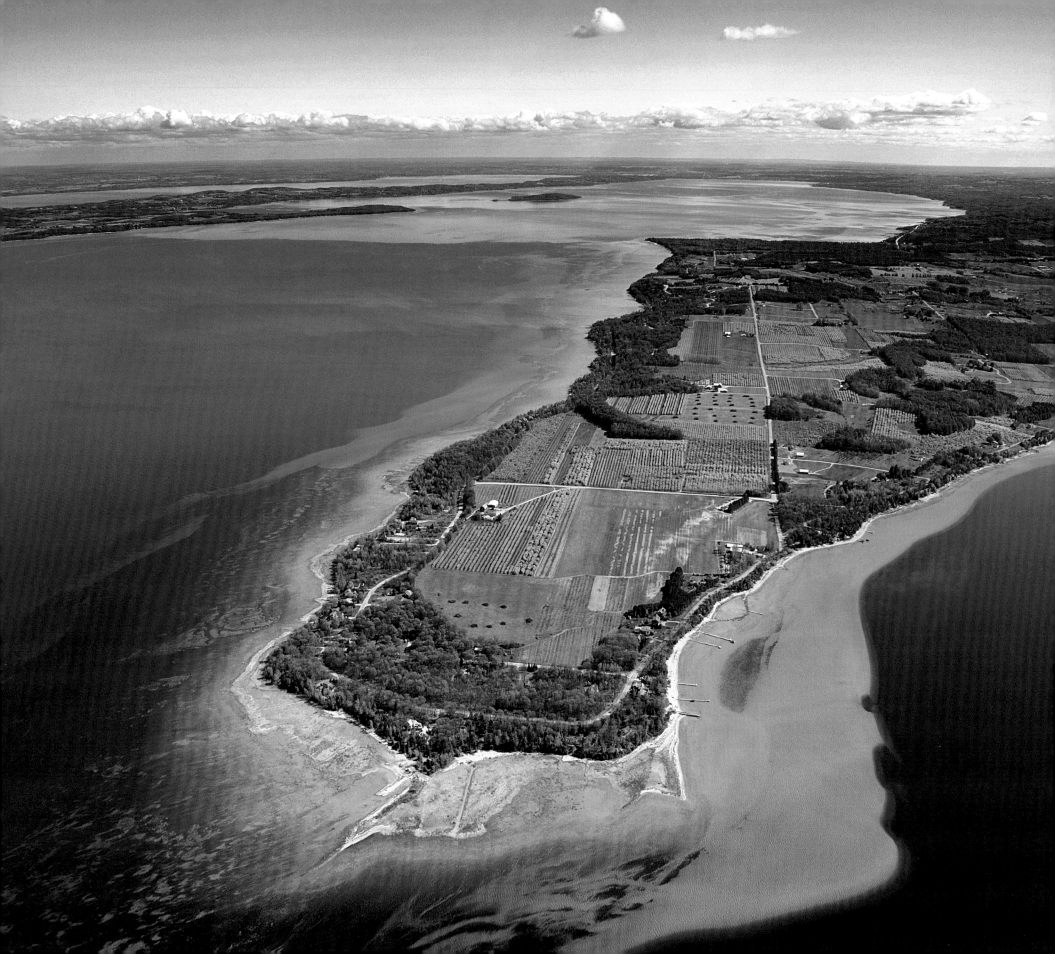

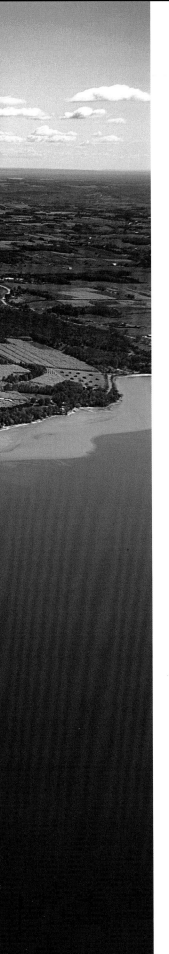

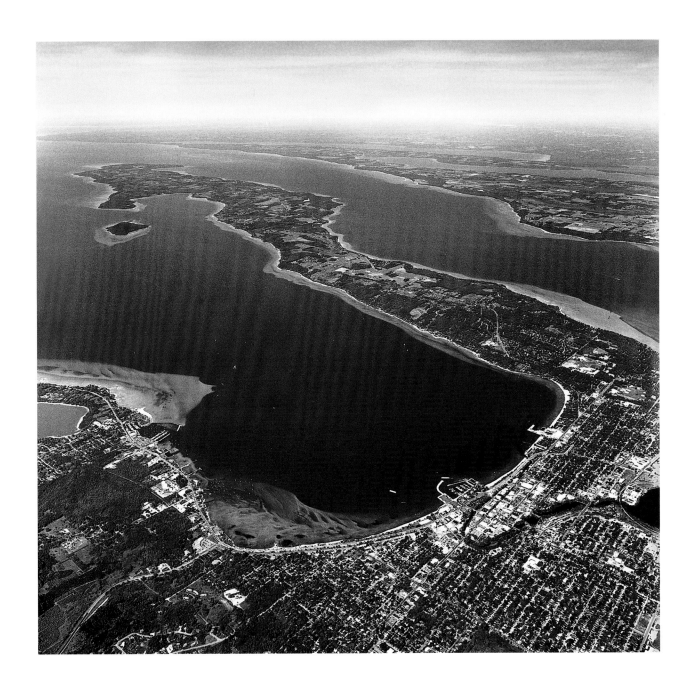

Grand Traverse Bay

Stoney Point

Shipwreck remains

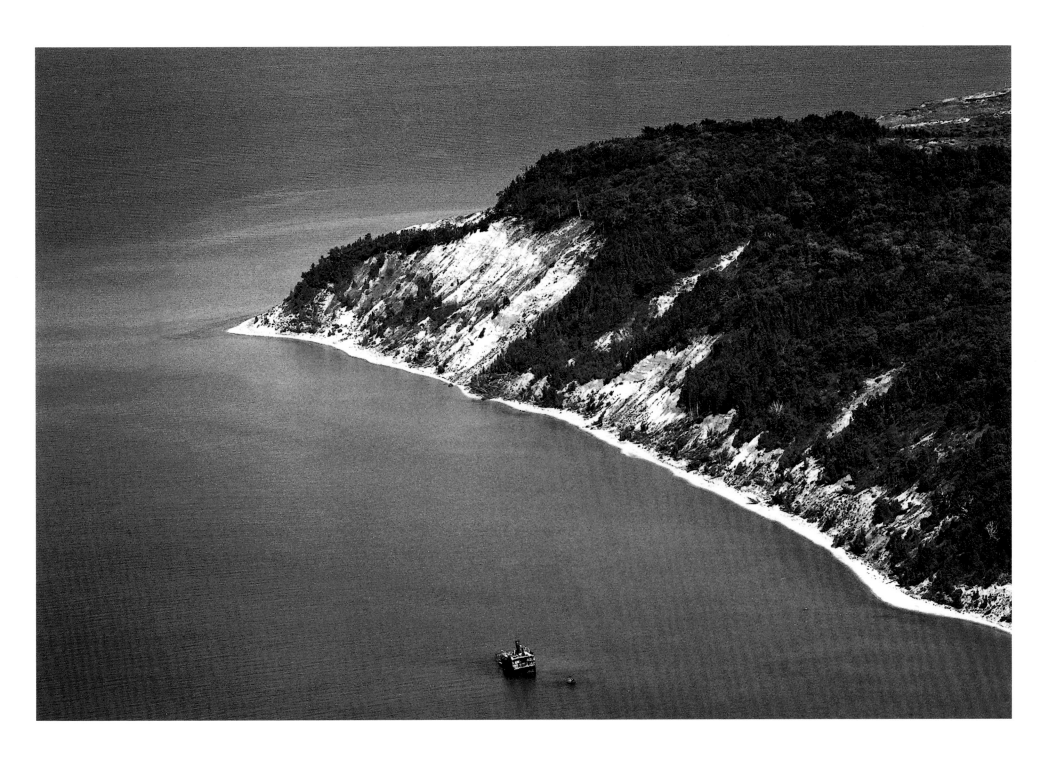

South Manitou Island

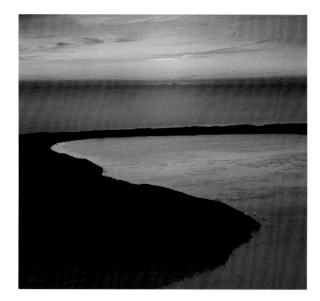

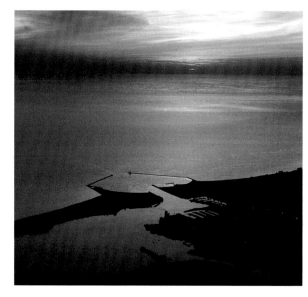

Platte Lake sunset

Ludington sunset

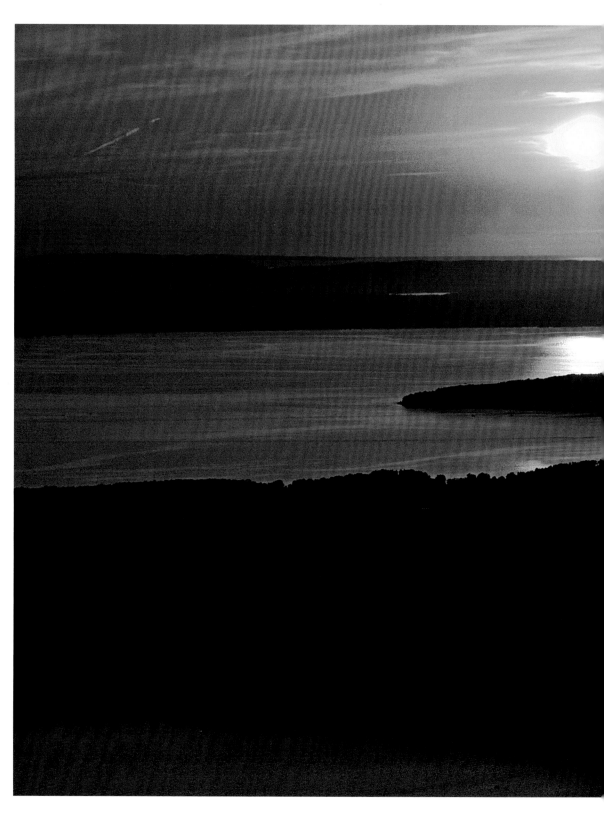

Power Island sunset

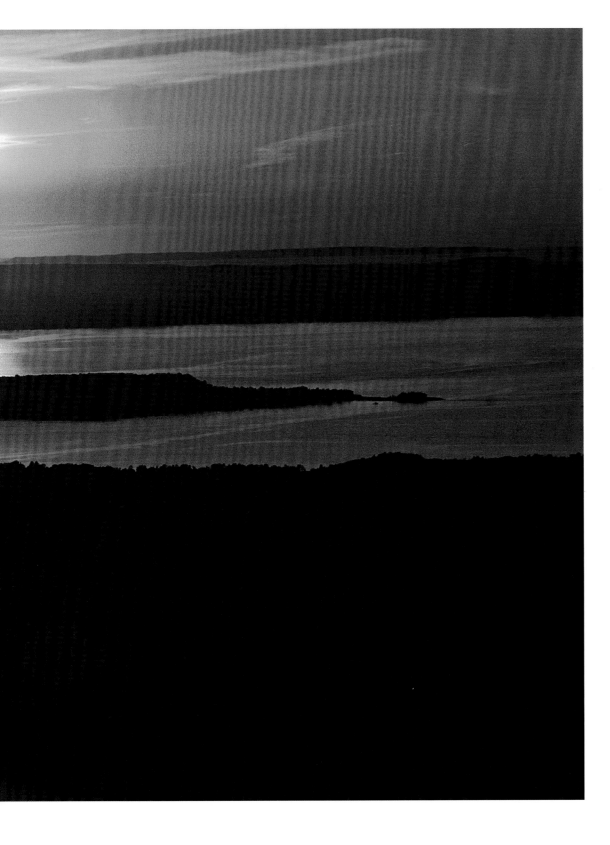

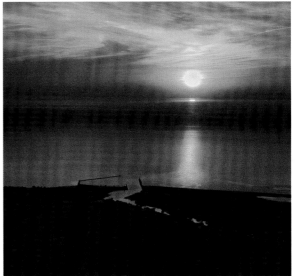

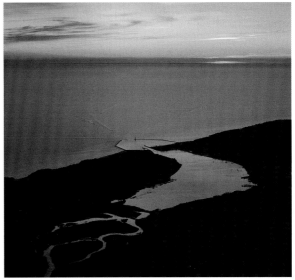

Manistee sunset

Frankfort sunset

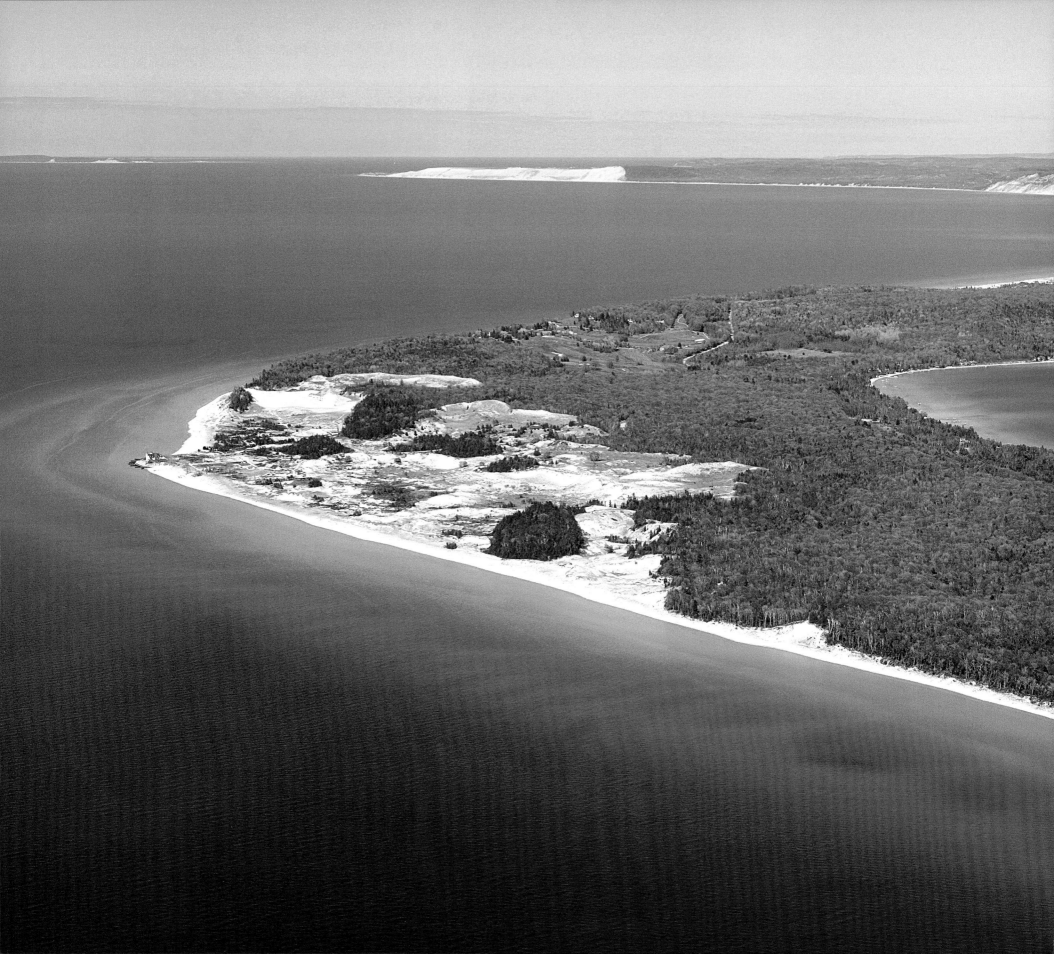

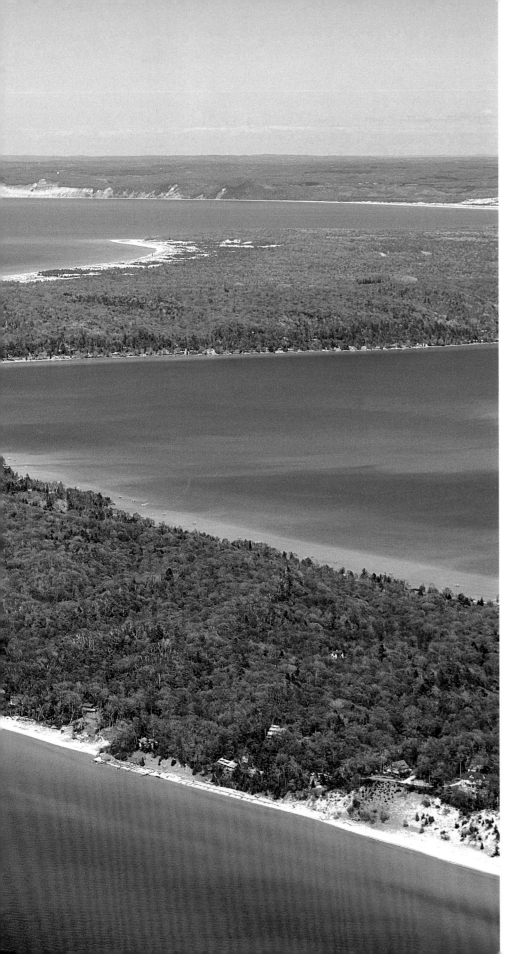

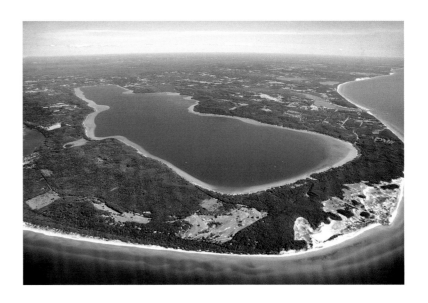

Crystal Lake

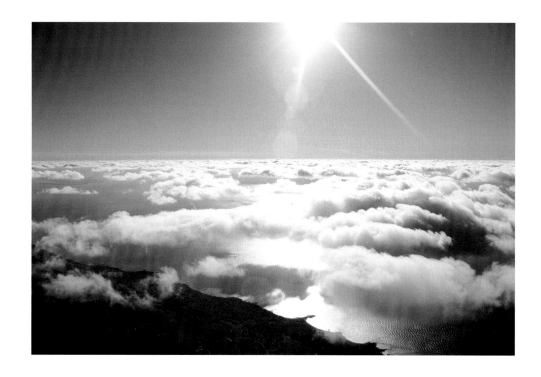

Clouds over the shoreline

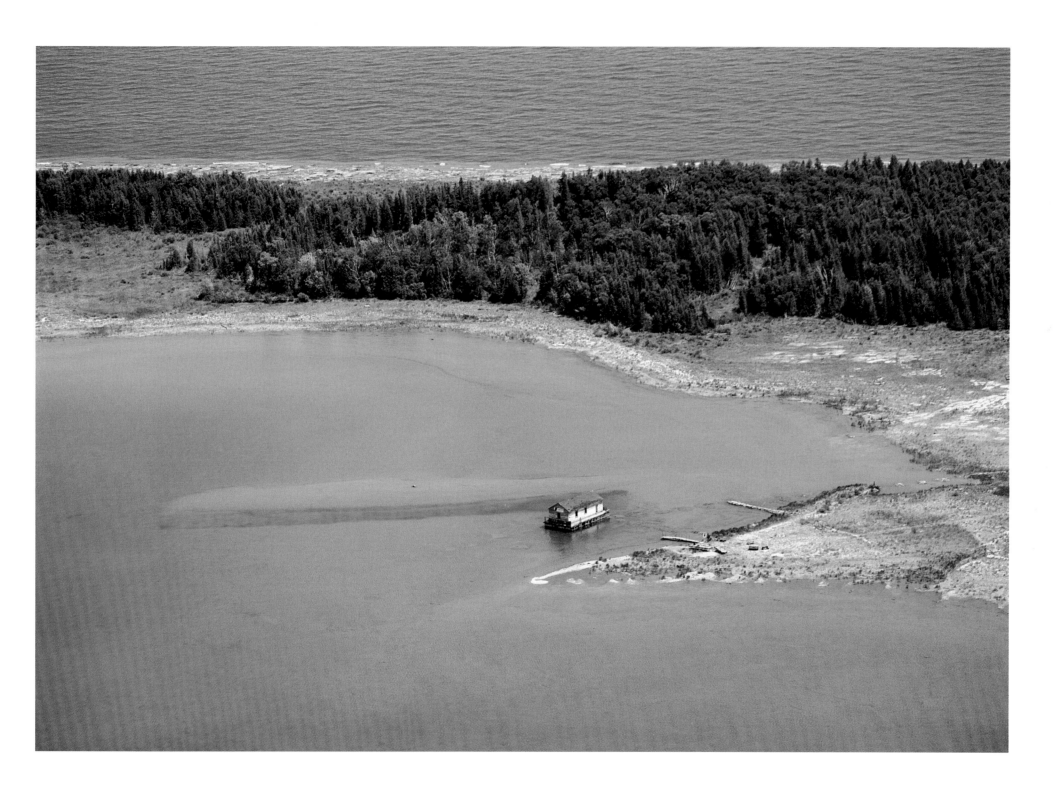

Thunder Bay Island

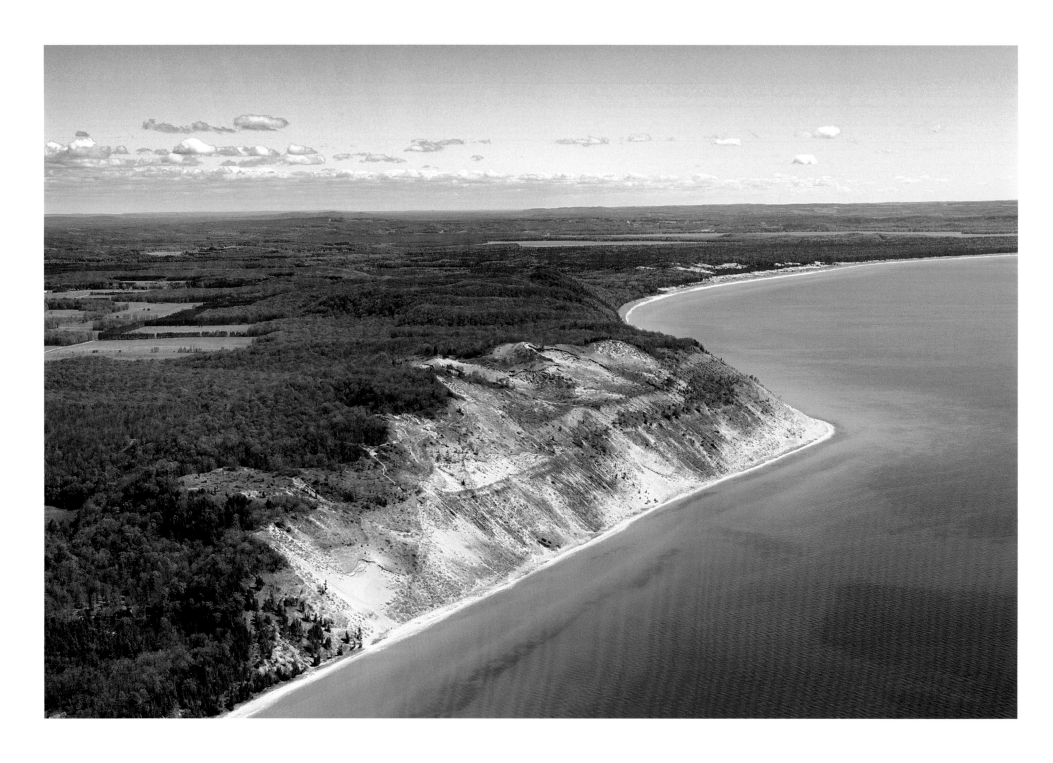

Empire Bluffs

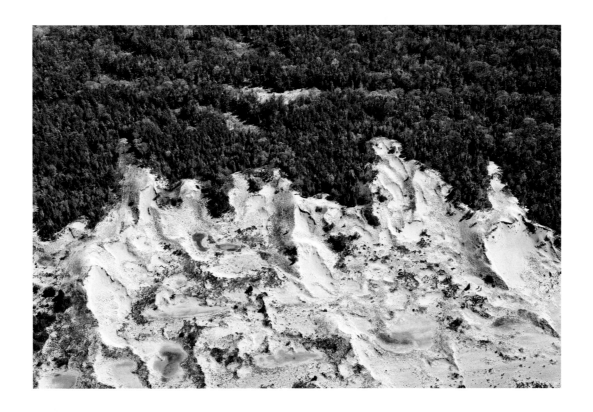

Sand & trees

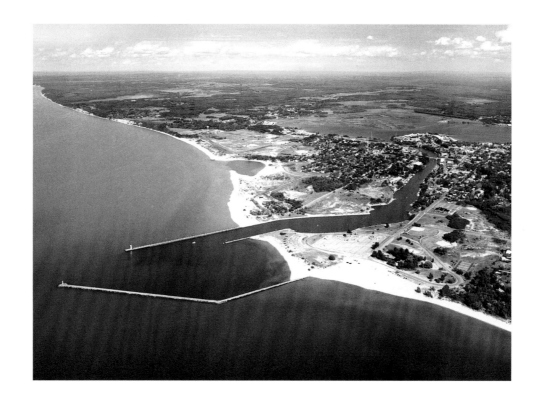

Manistee historical view

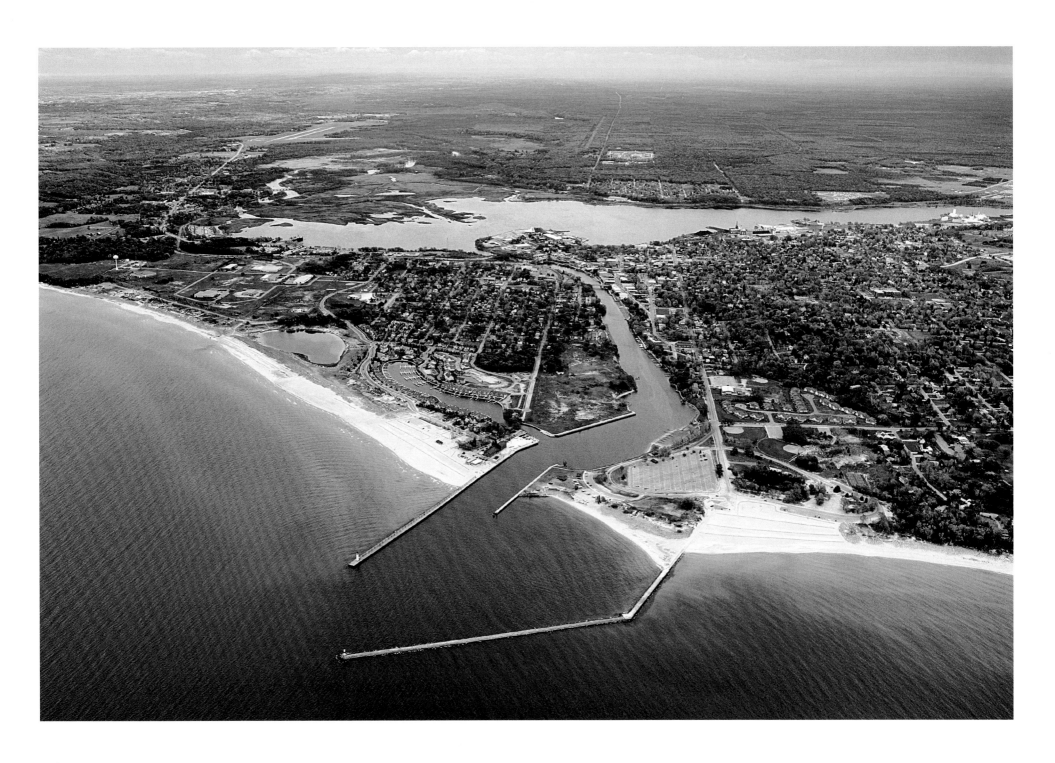

Manistee in the fall

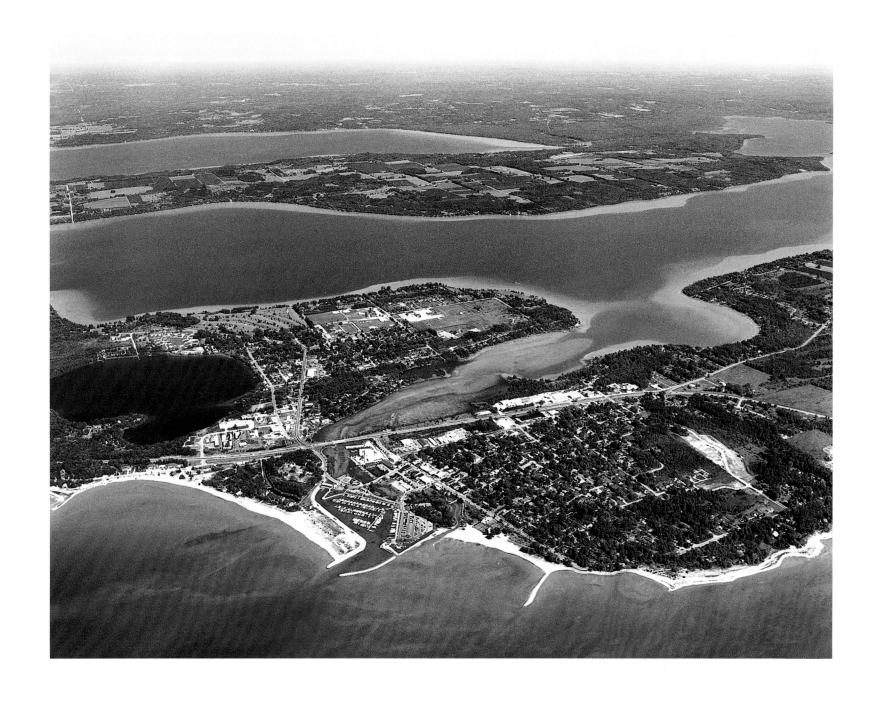

Elk Rapids

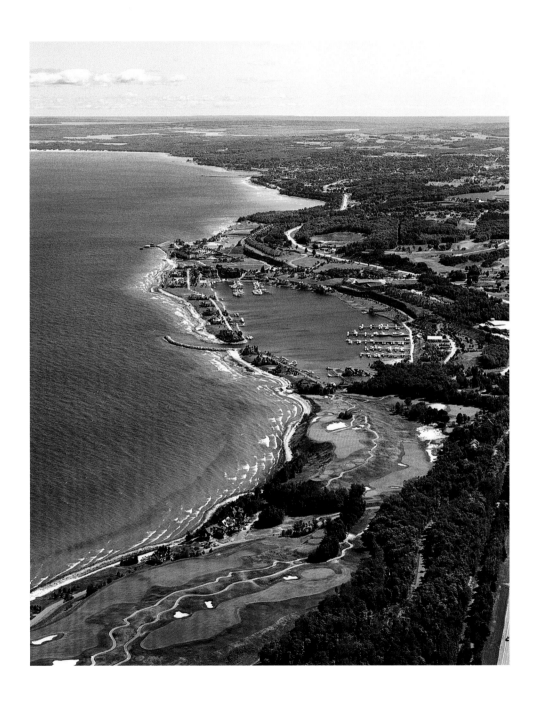

Bay Harbor

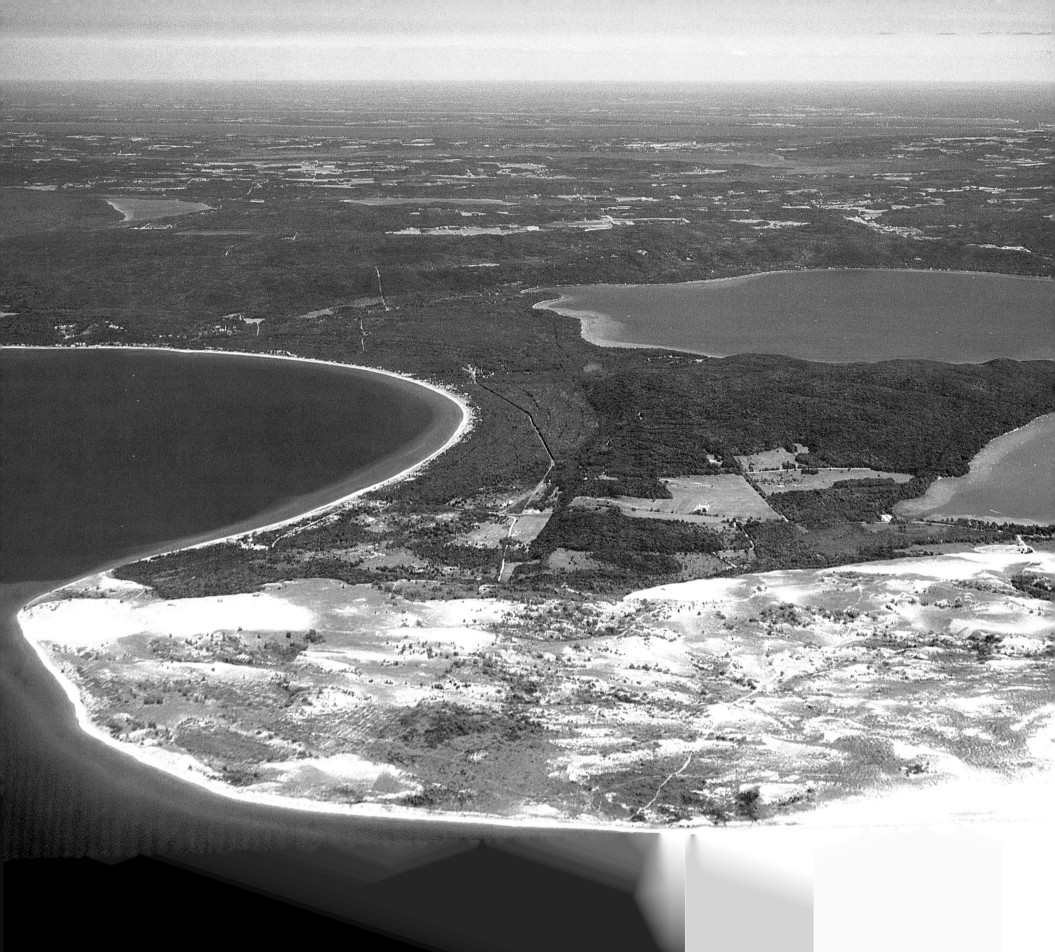

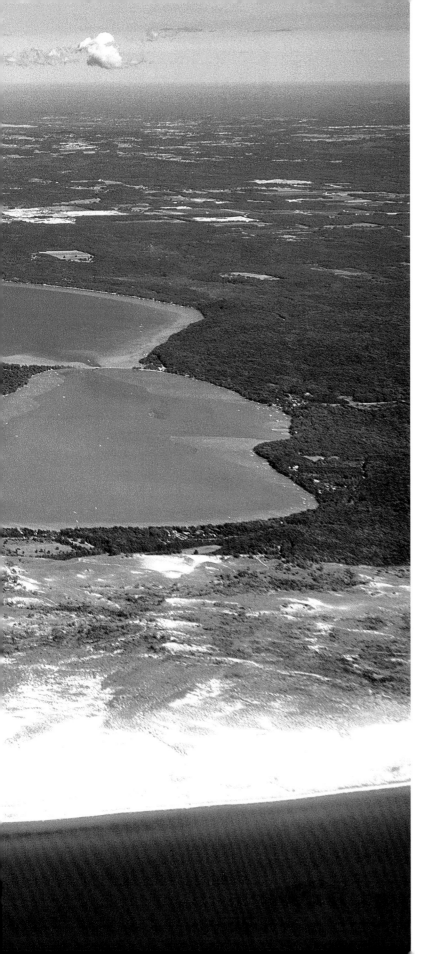

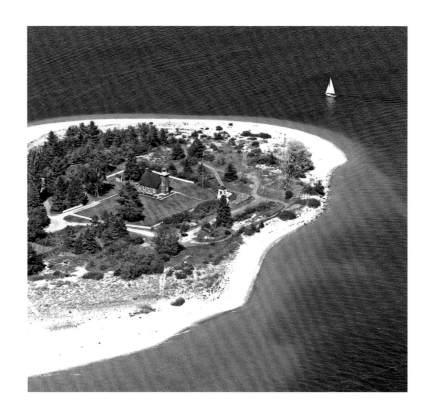

Little Traverse Bay Lighthouse

Glen Lake

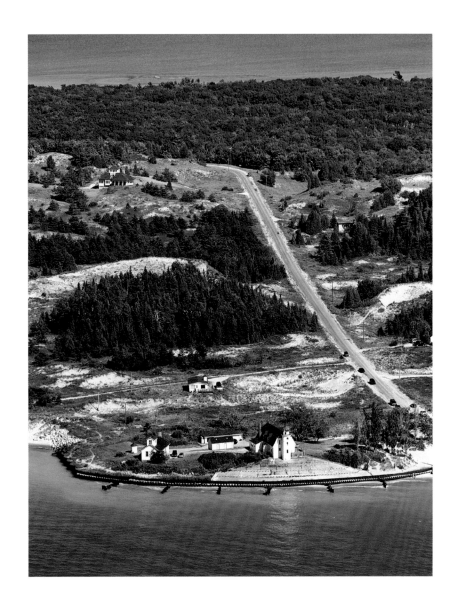

Point Betsie Lighthouse

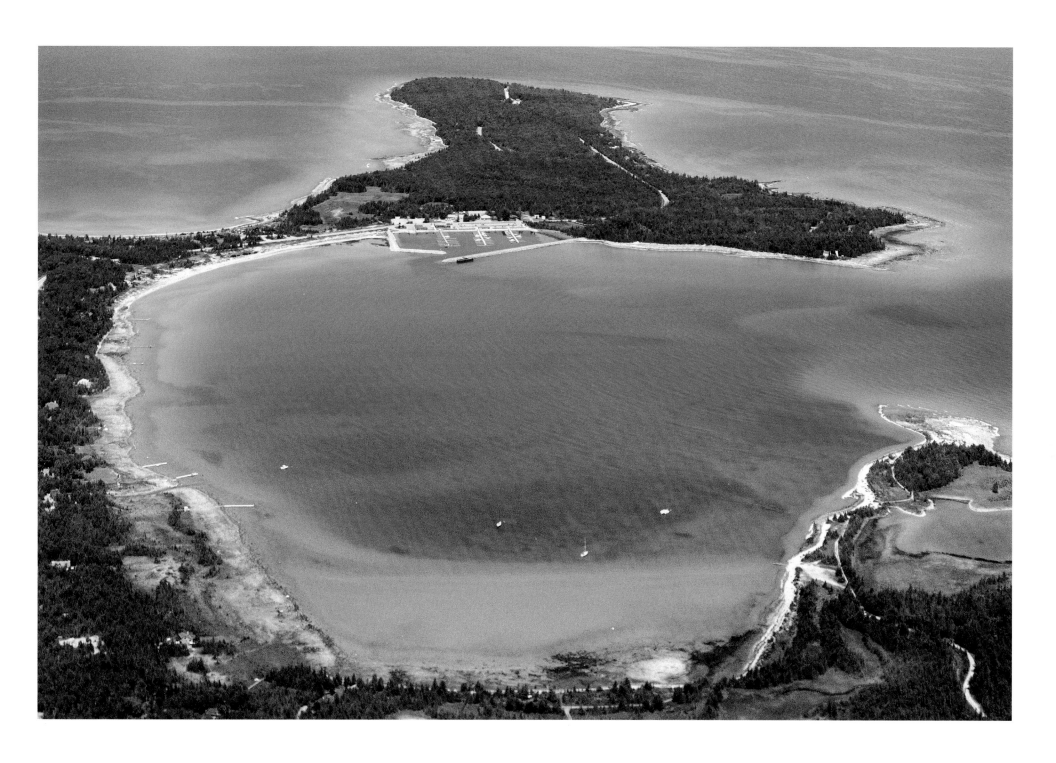

Presque Isle Harbor

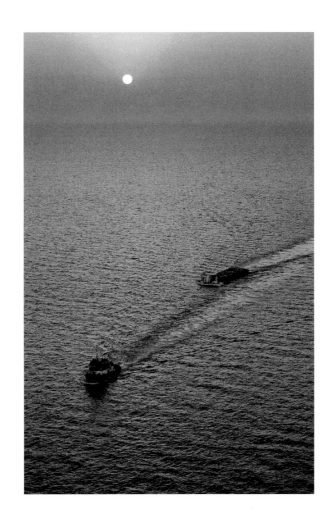

The Meribeth Andrie

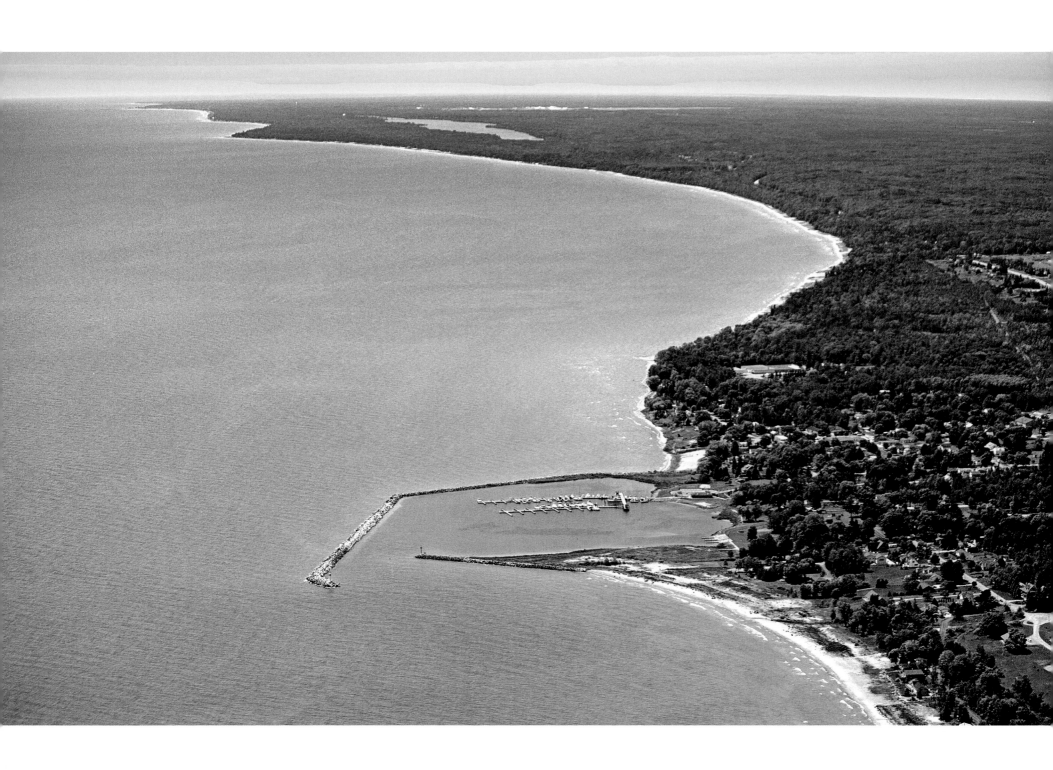

Harrisville Harbor

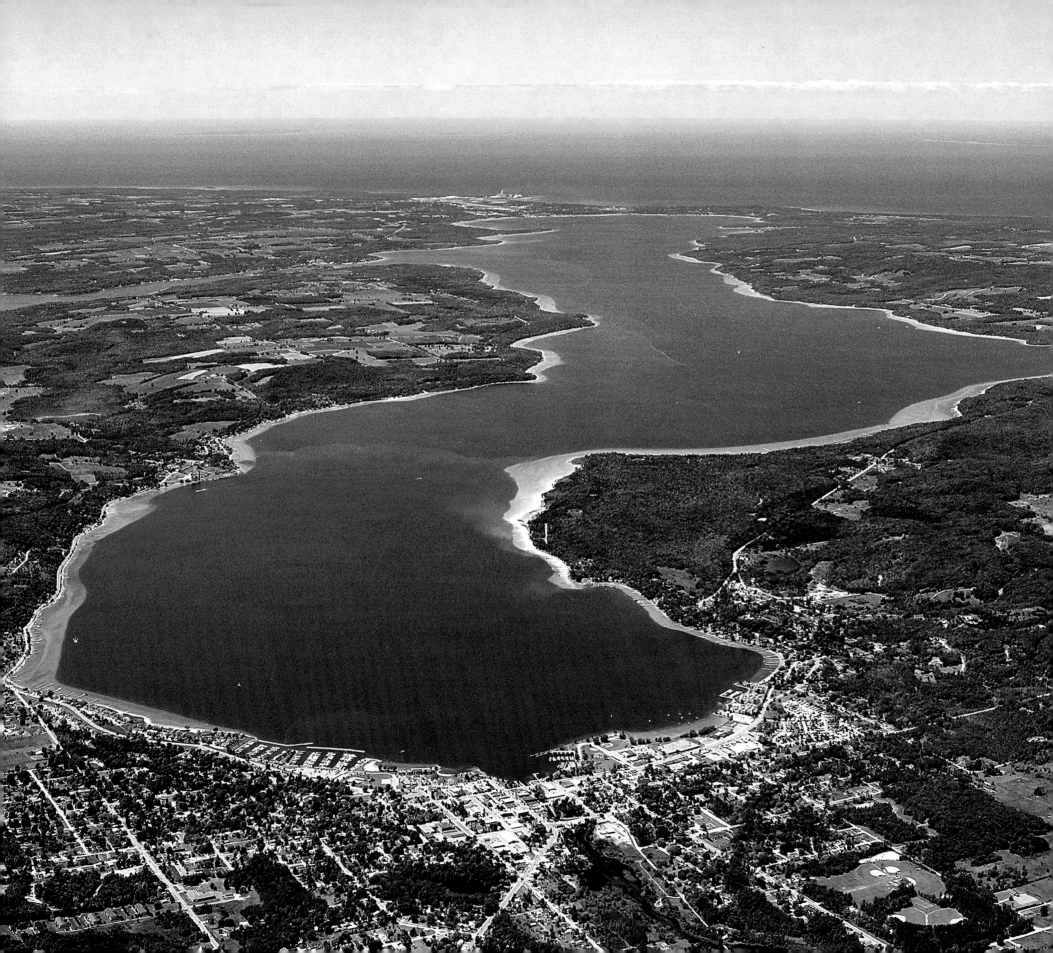

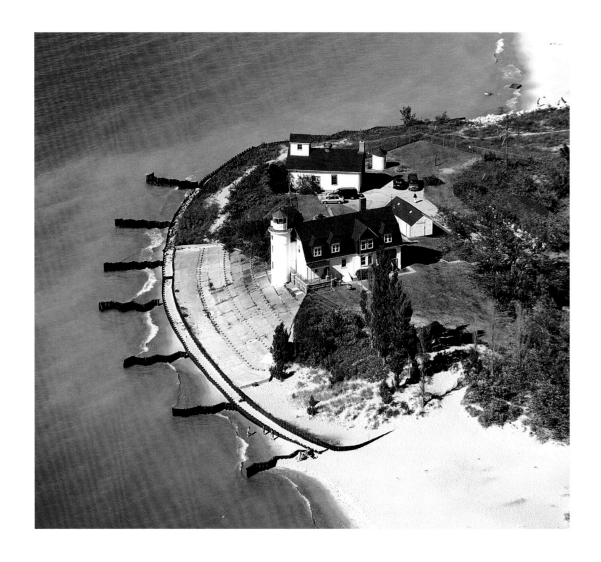

Point Betsie Lighthouse

Boyne City

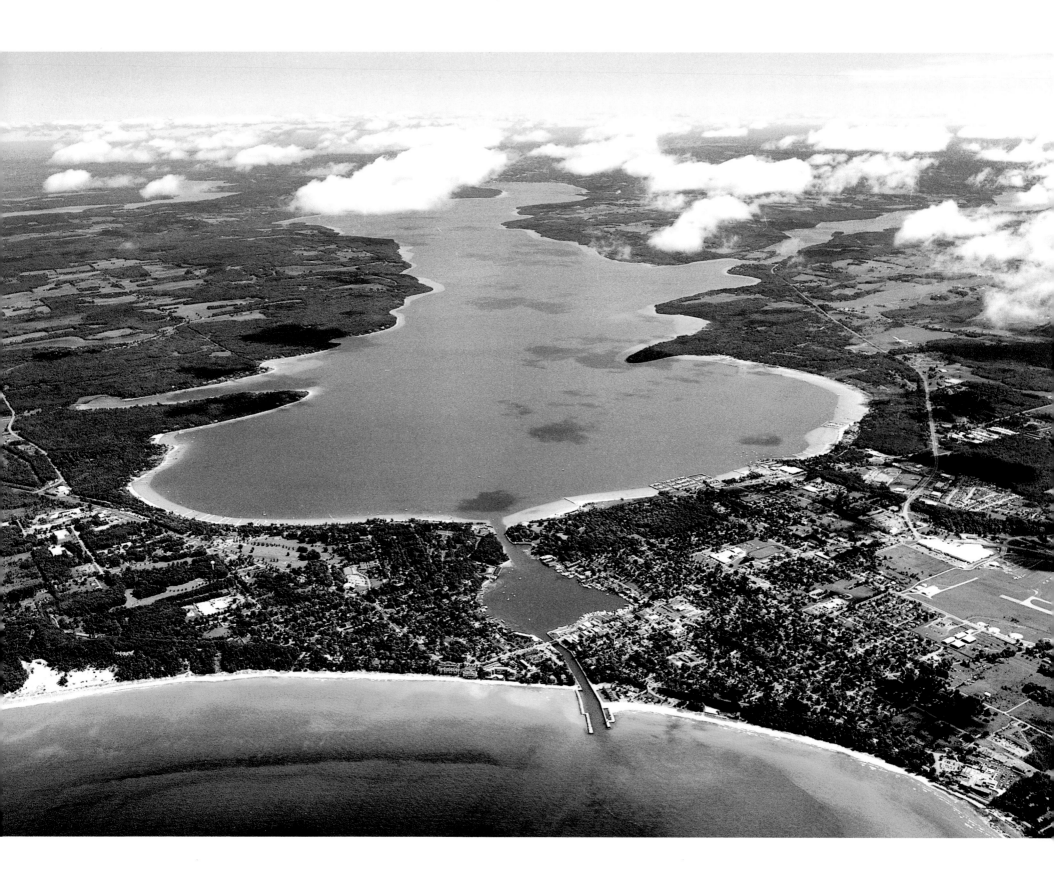

Charlevoix

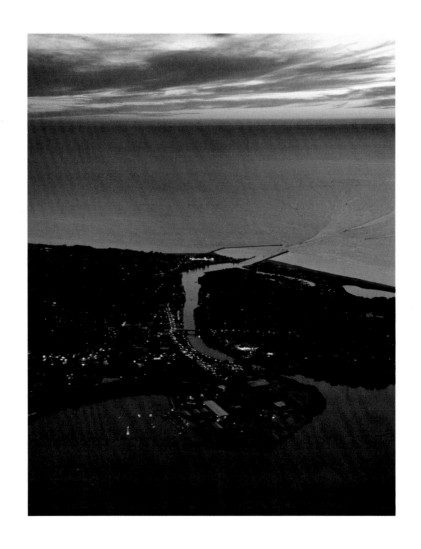

Manistee sunset

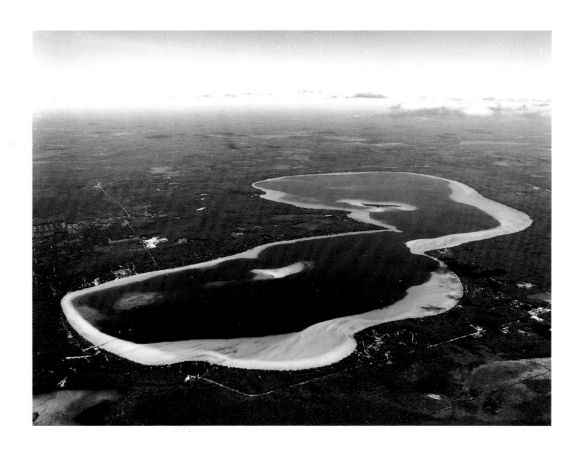

Higgins Lake

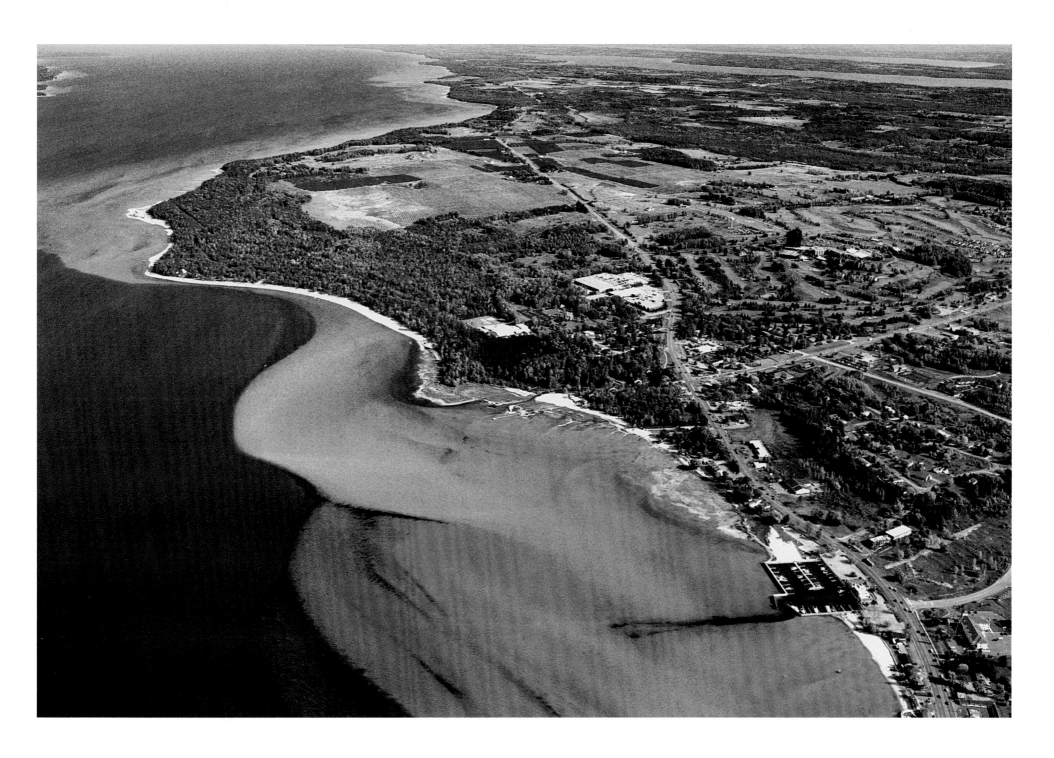

Acme

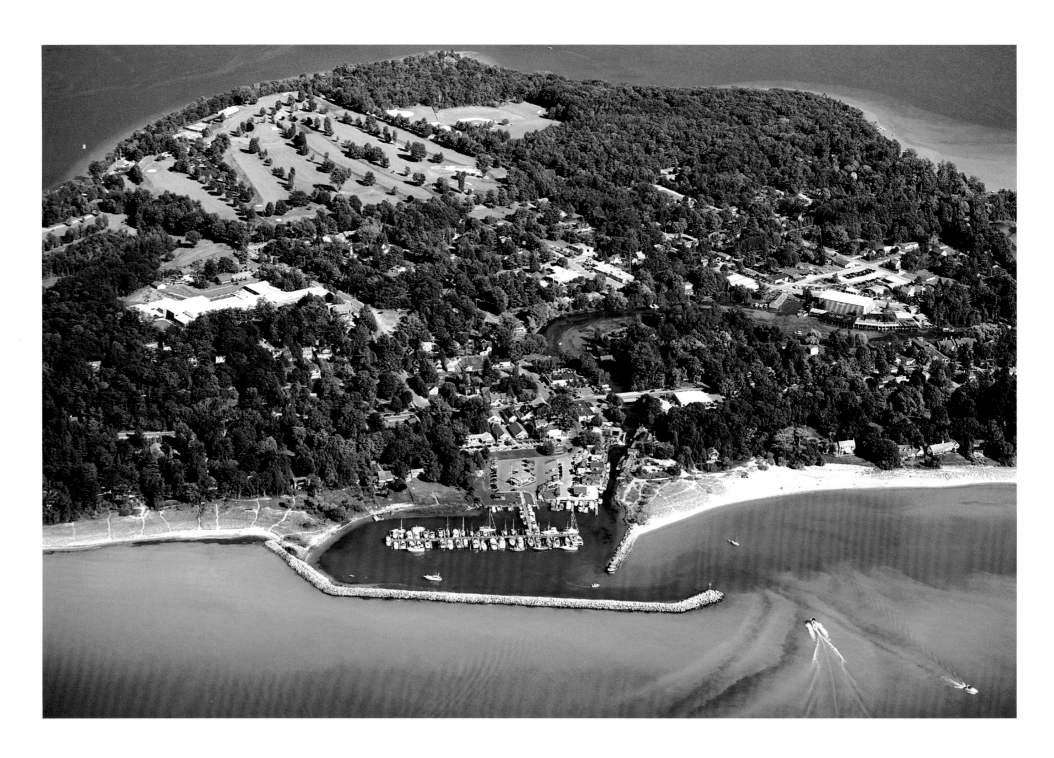

Leland

Algae on an inland lake

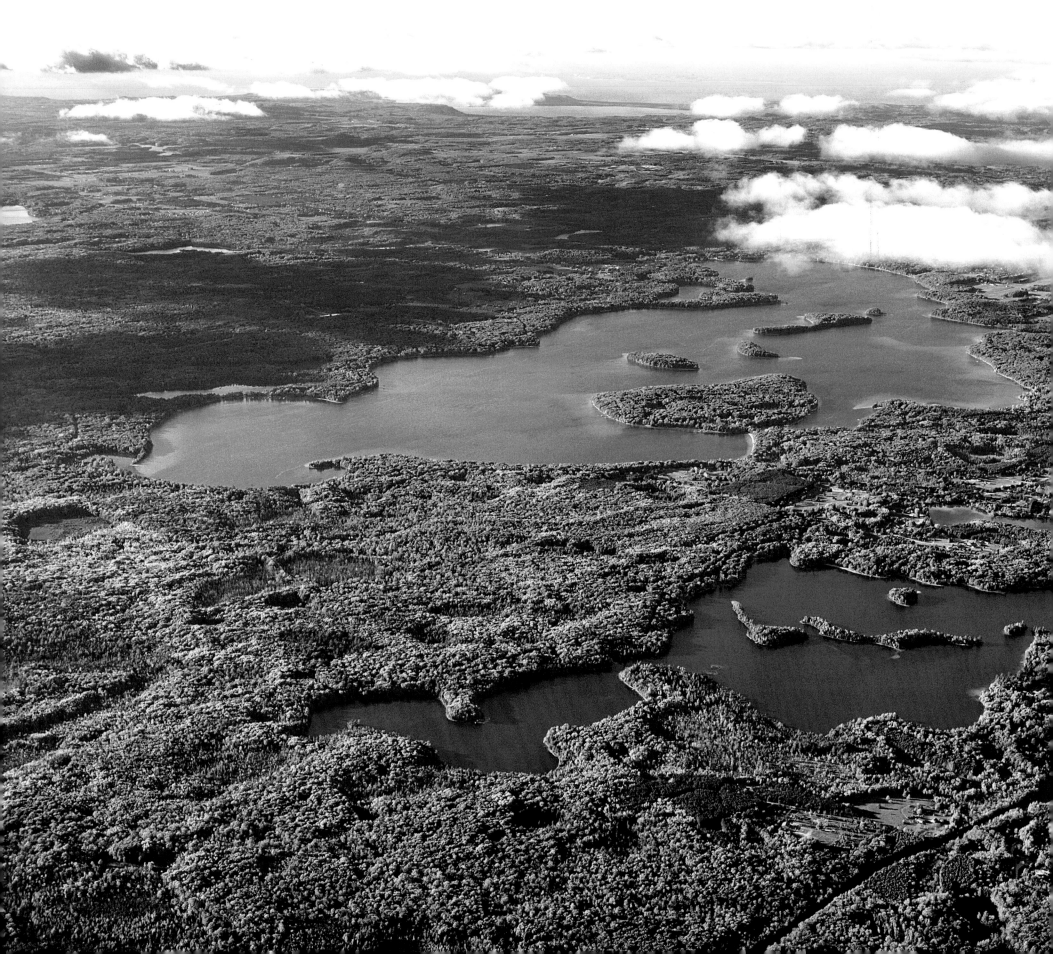

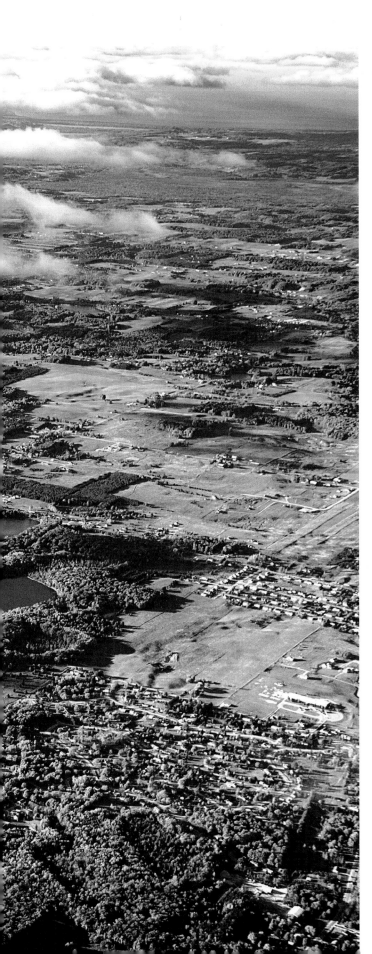

Water patterns

Bass Lake & Long Lake

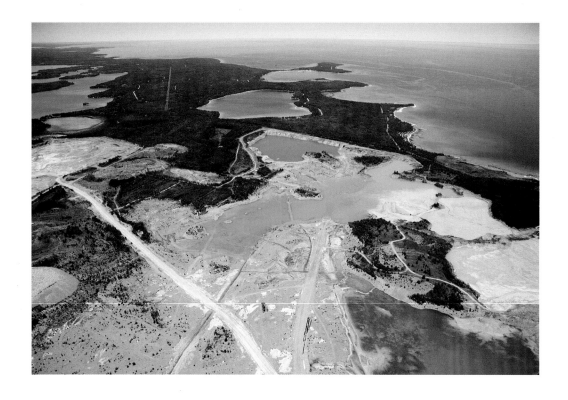

Stoneport

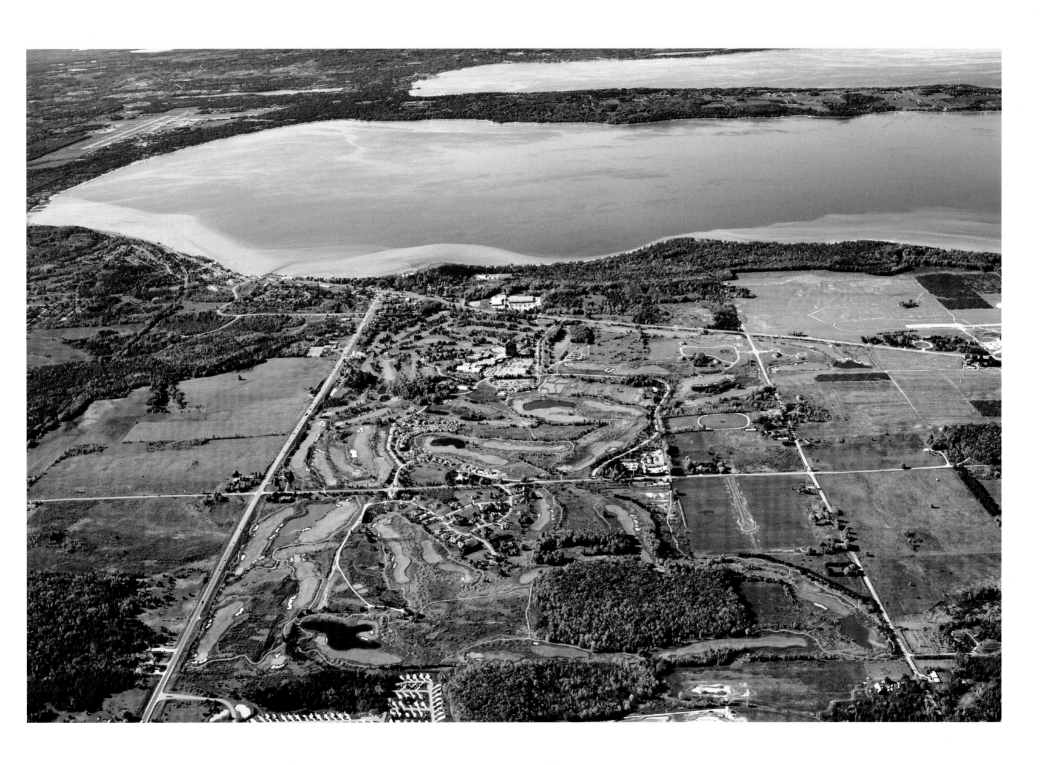

Acme

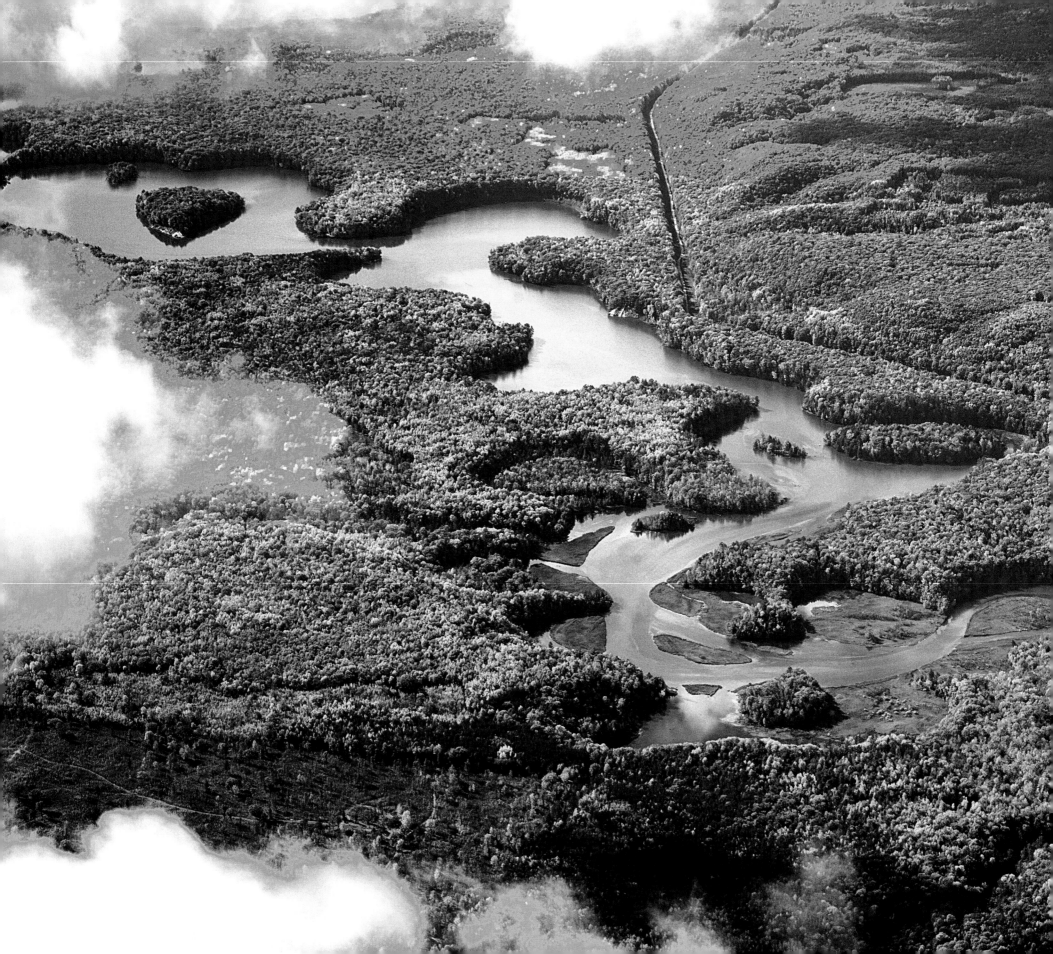

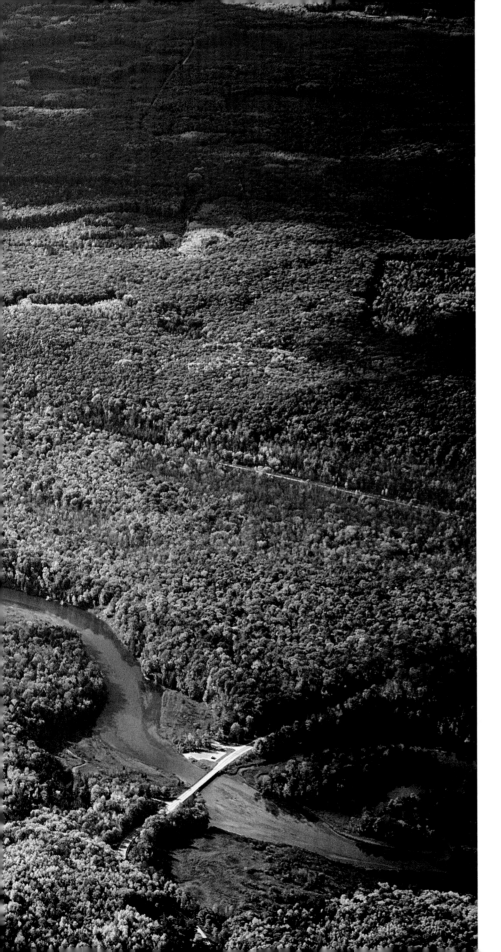

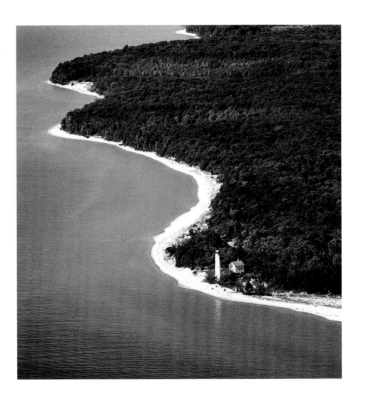

South Manitou Island Lighthouse

Manistee River in the fall

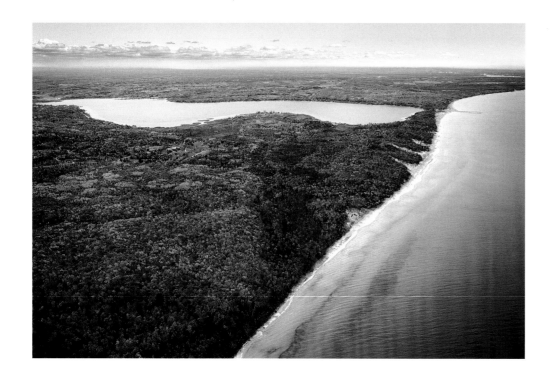

Portage Lake & Lake Michigan

Mackinac Bridge

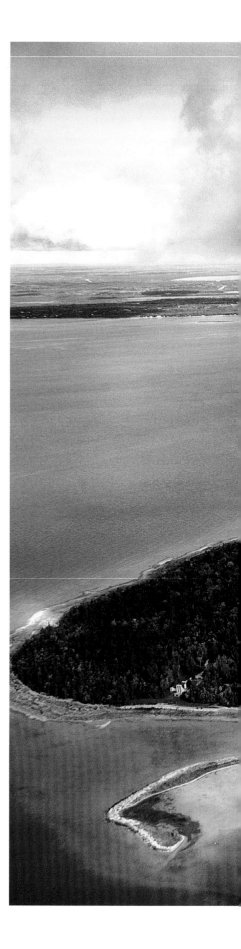

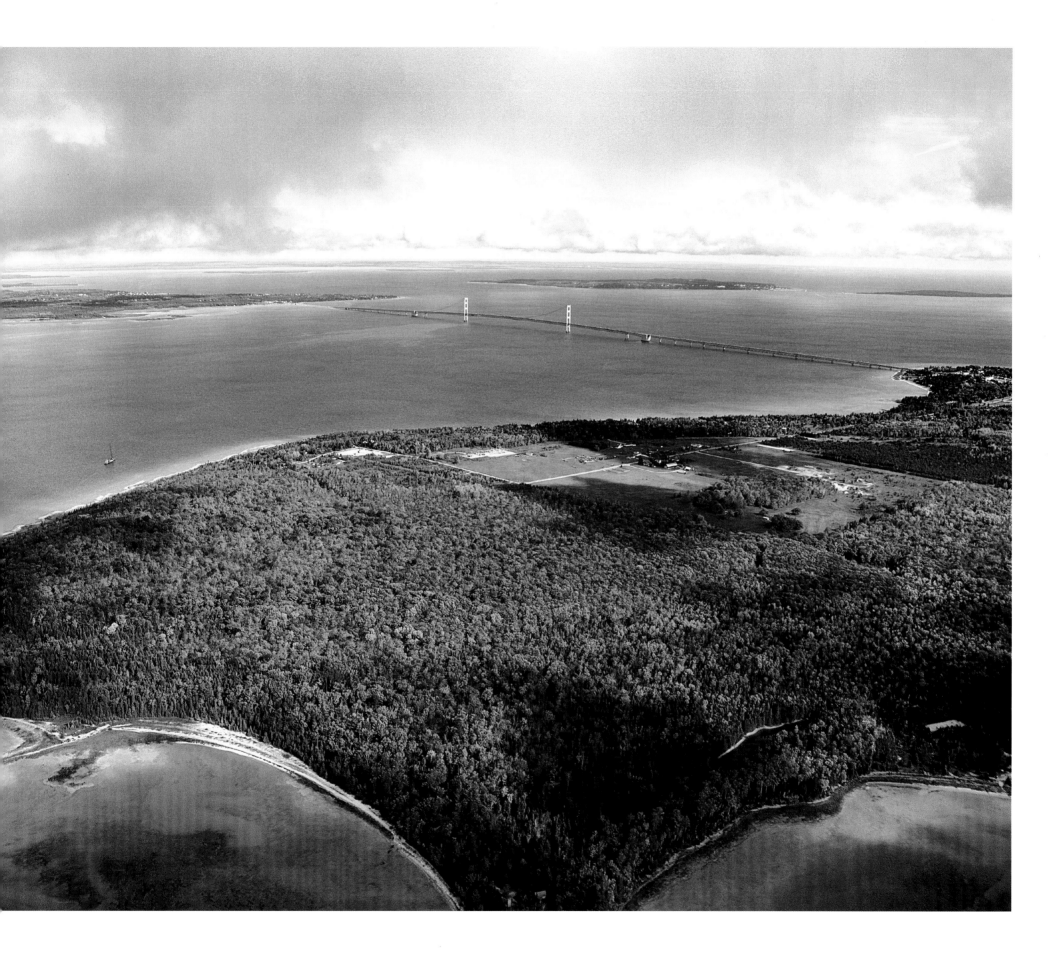

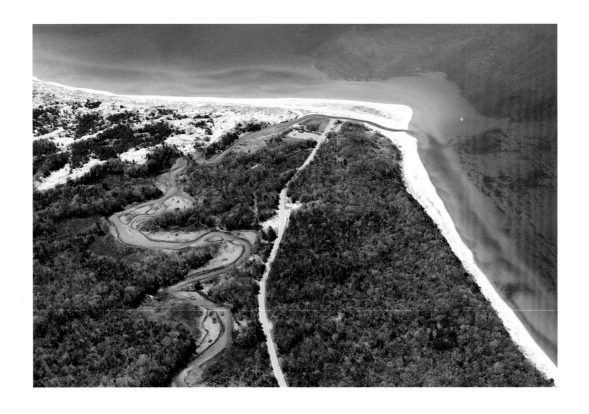

Platte River

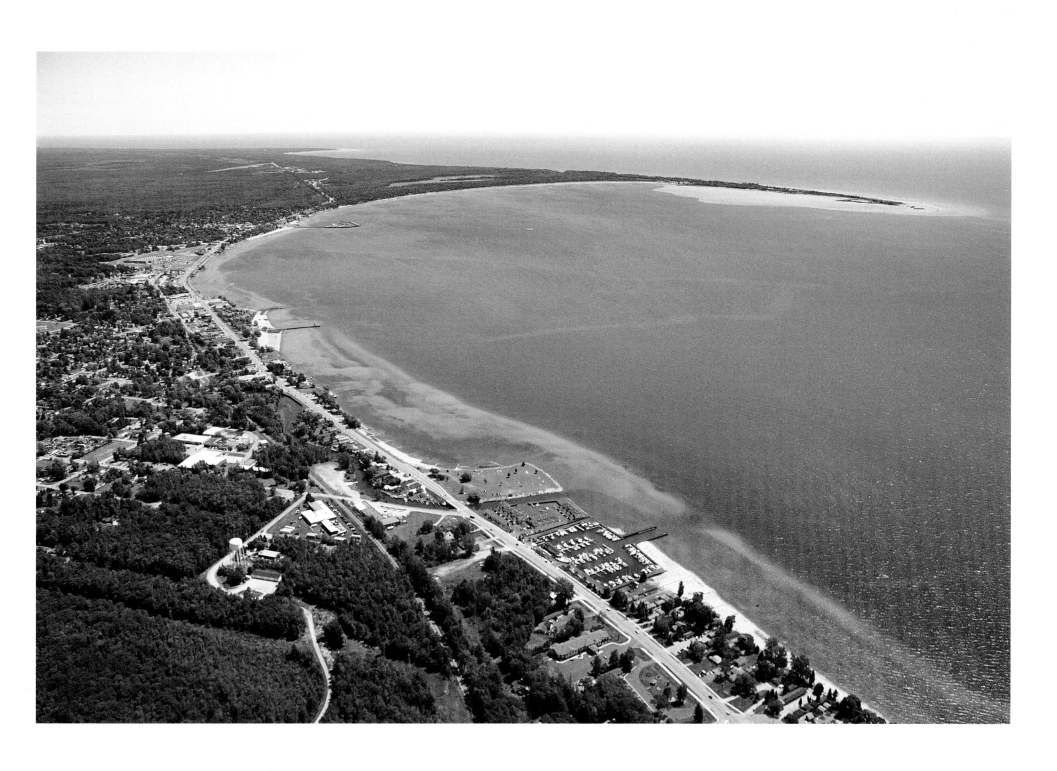

Tawas

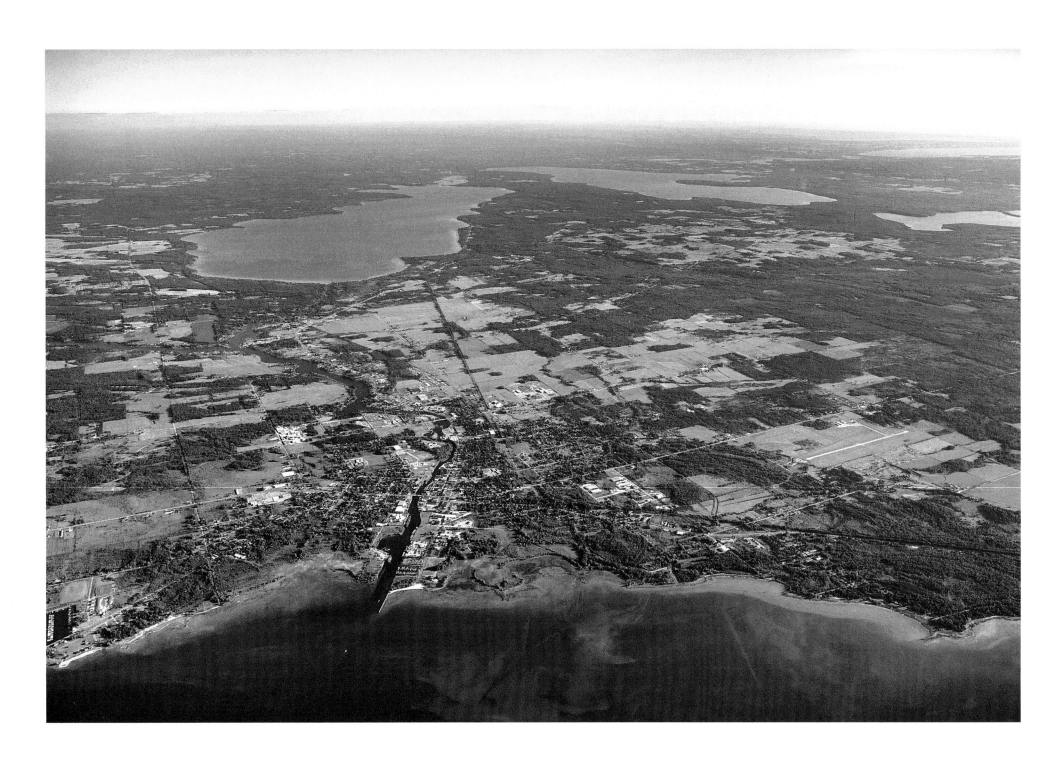

Michigan inland waterway

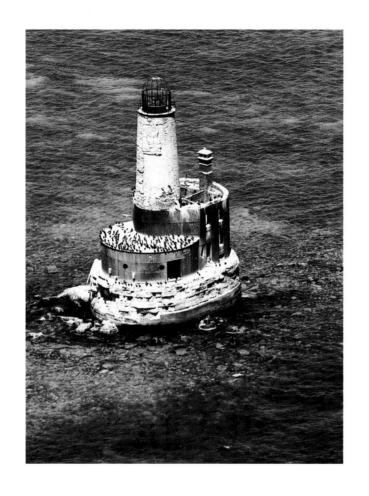

Waugoshance Lighthouse

Water patterns

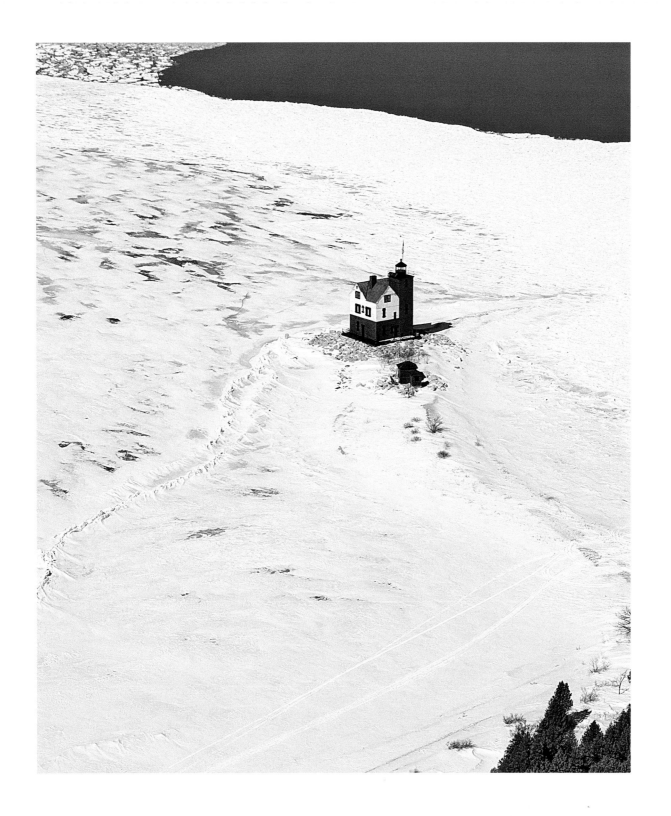

Round Island Lighthouse

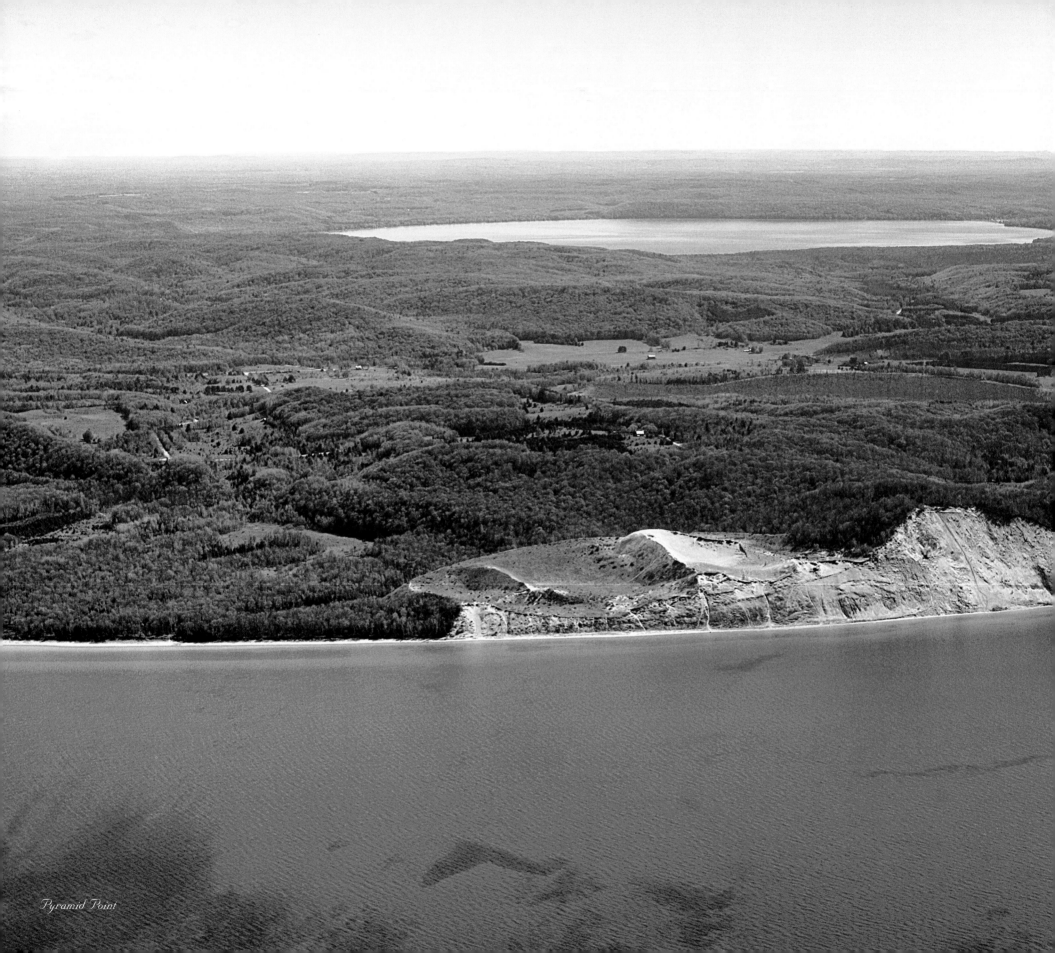

Pyramid Point

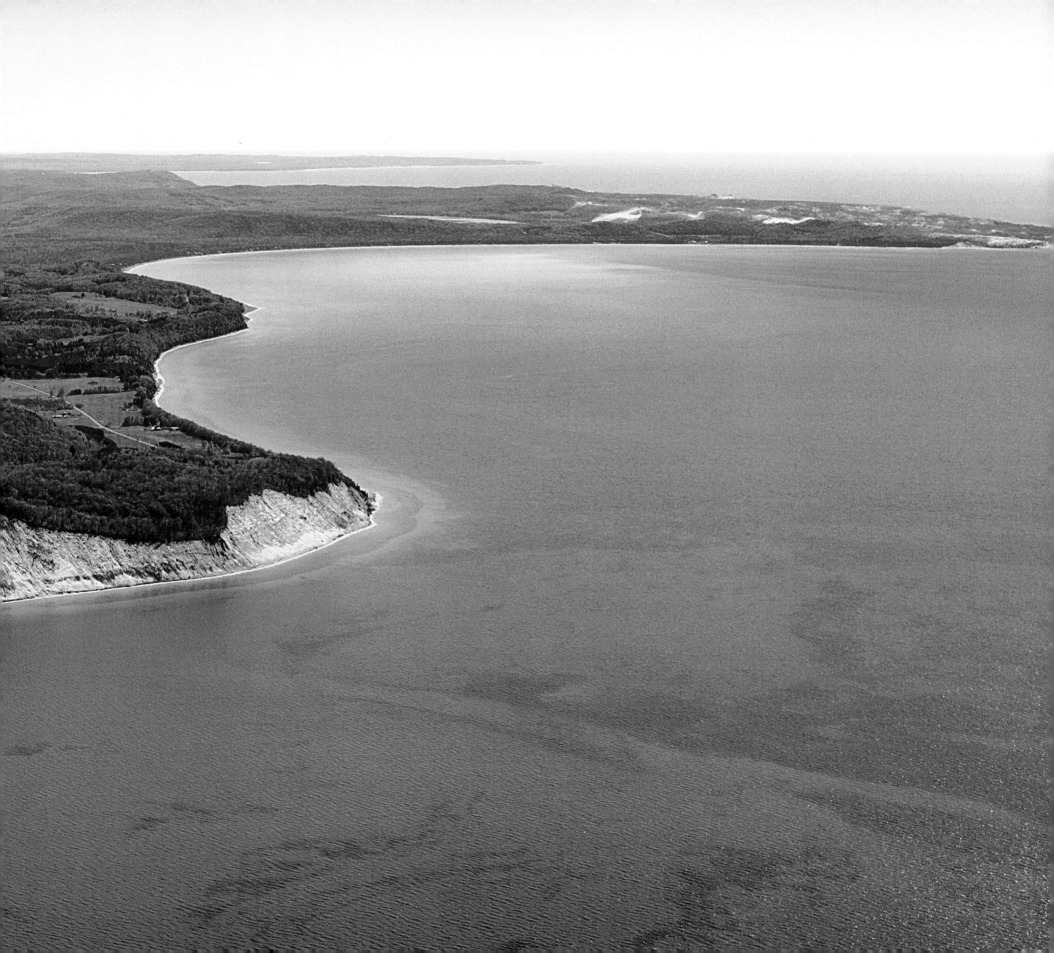

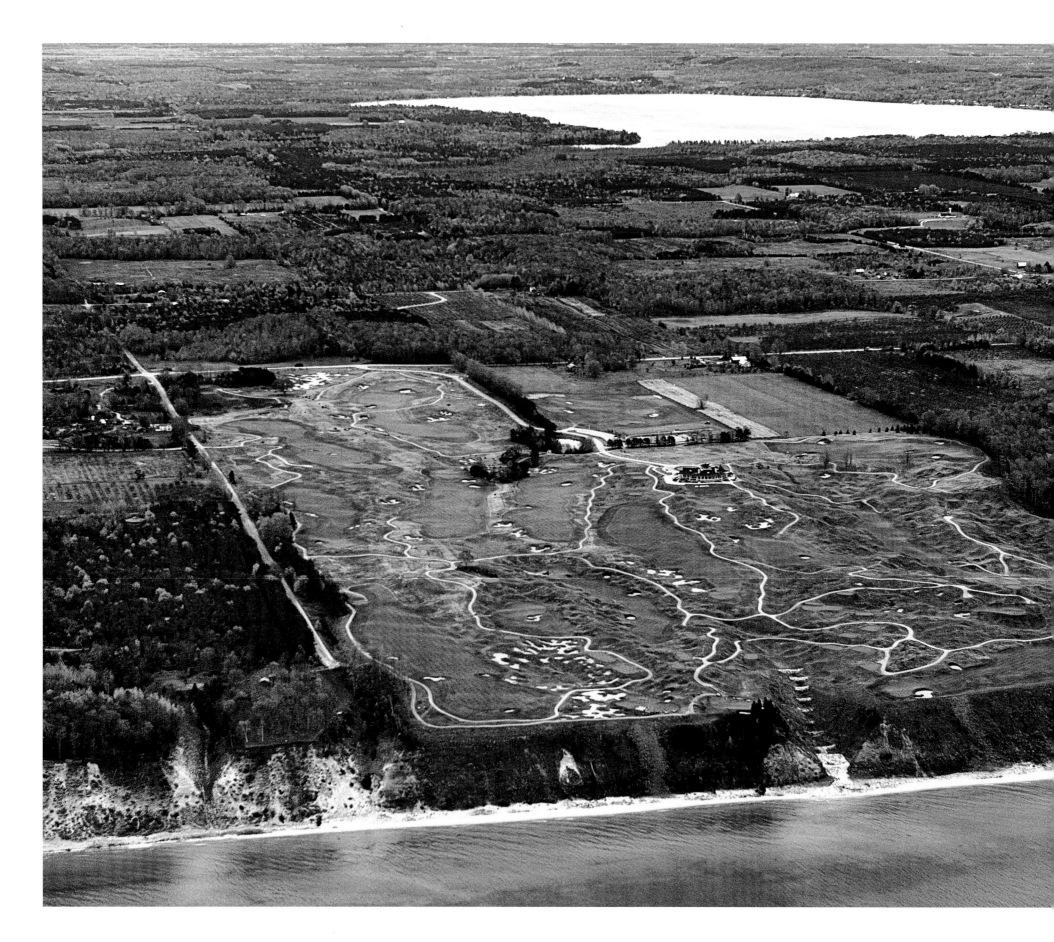

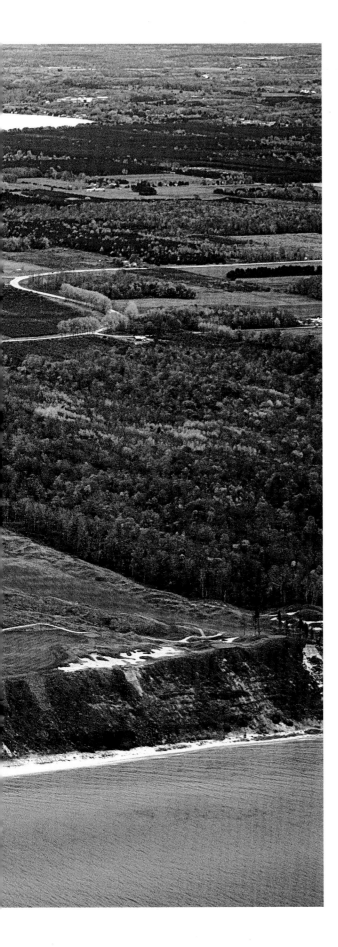

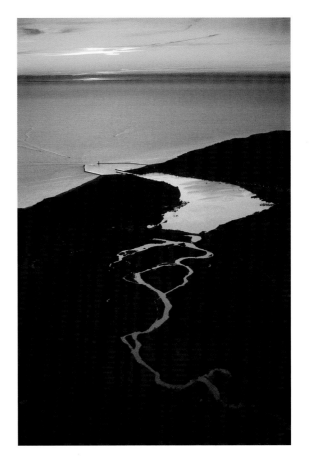

Frankfort sunset

Arcadia Bluffs

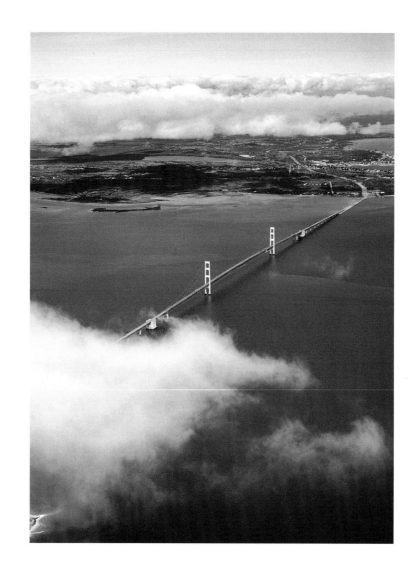

Mackinac Bridge

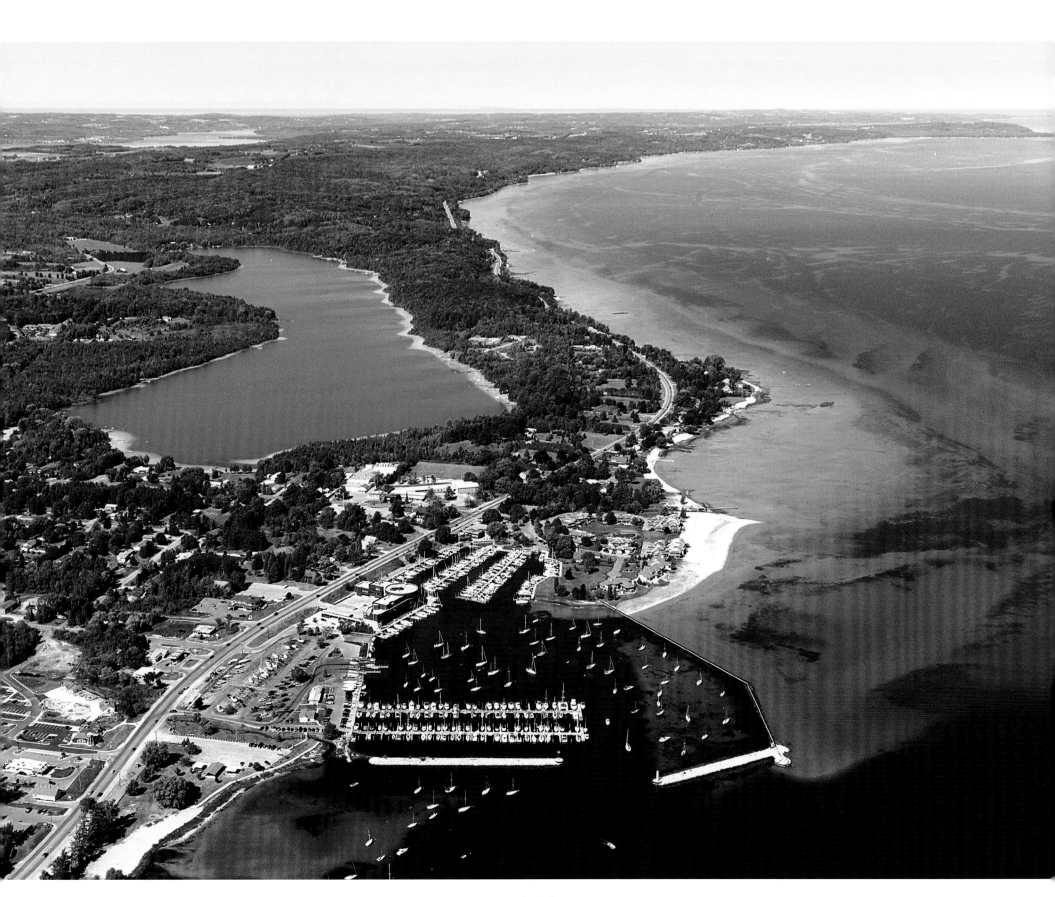

Grelickville

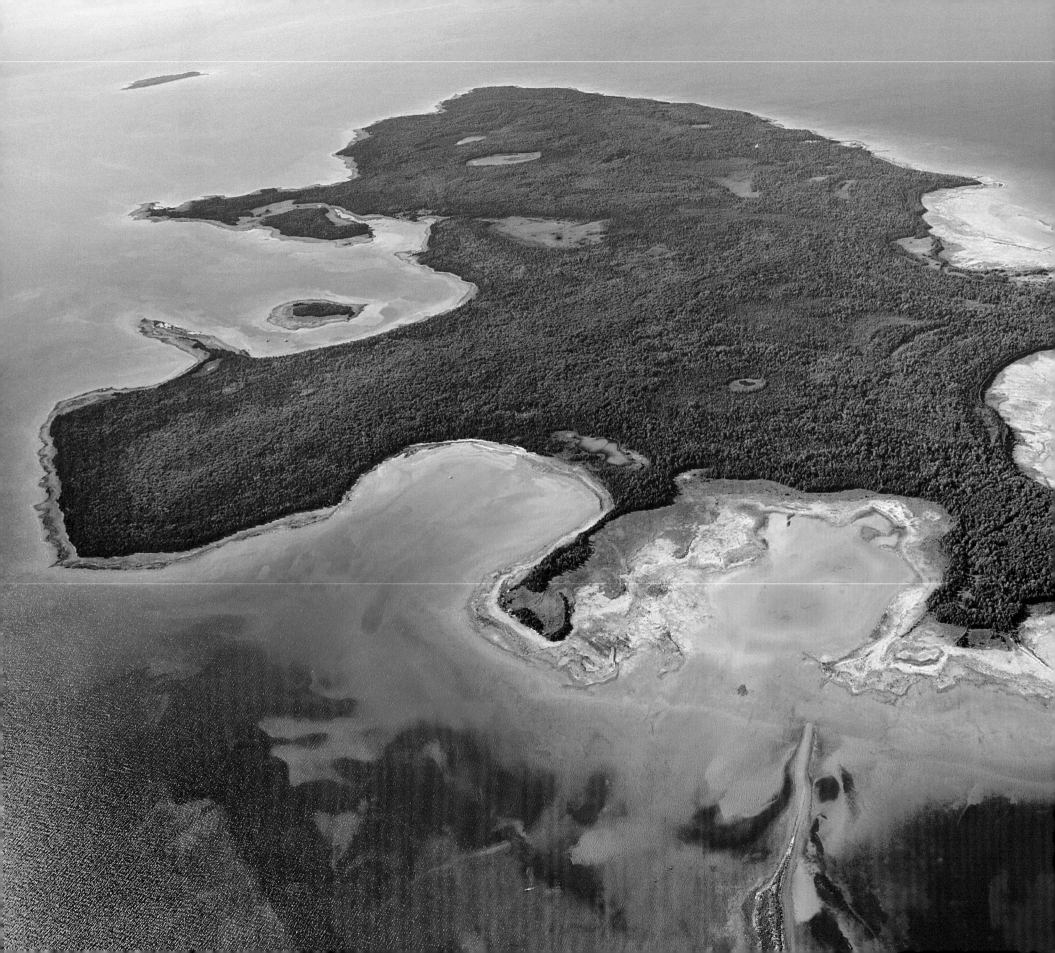

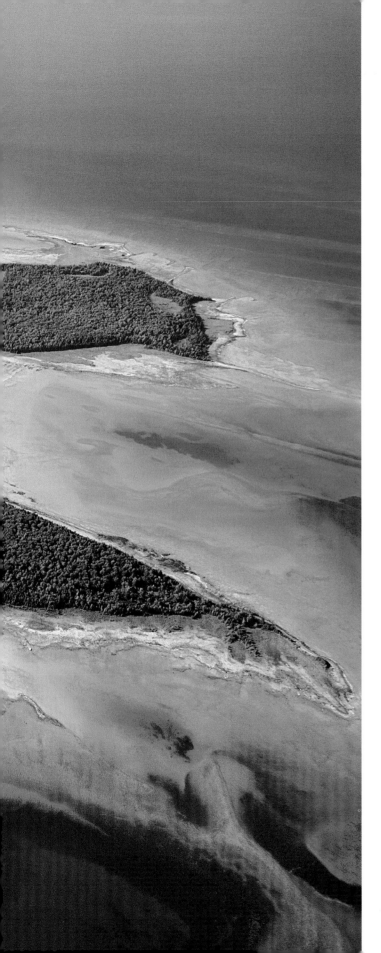

Hog Island

Garden Isle

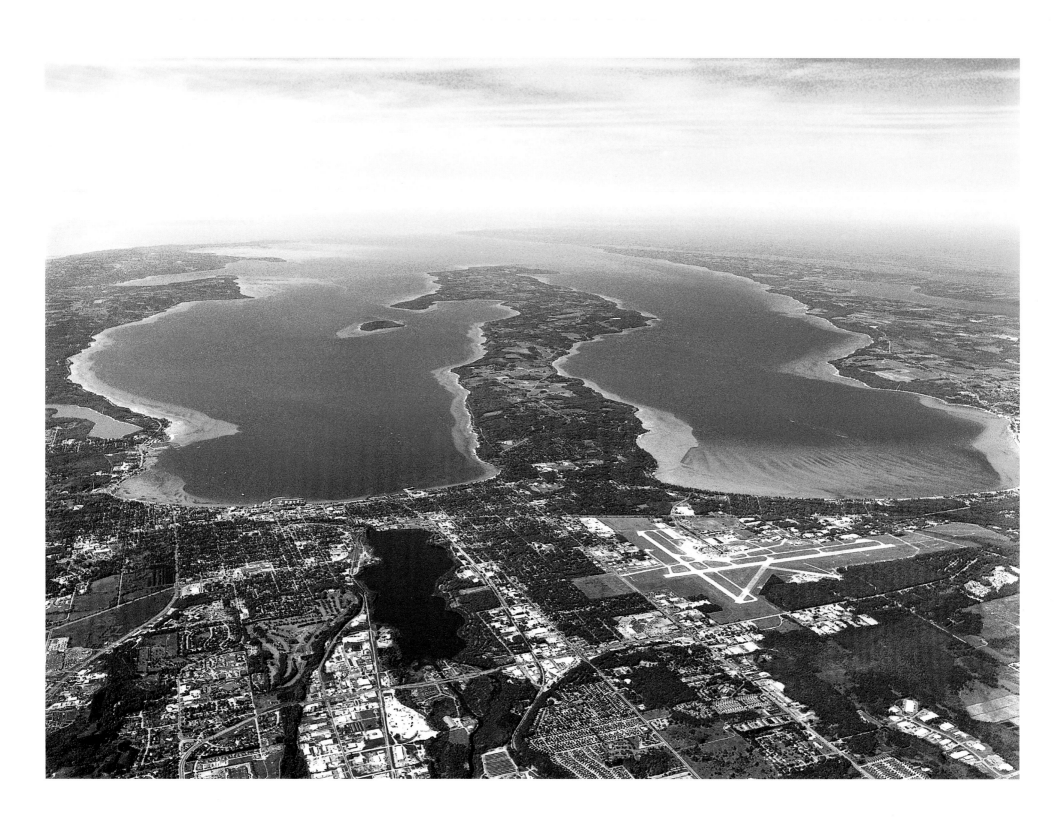

Grand Traverse Bay

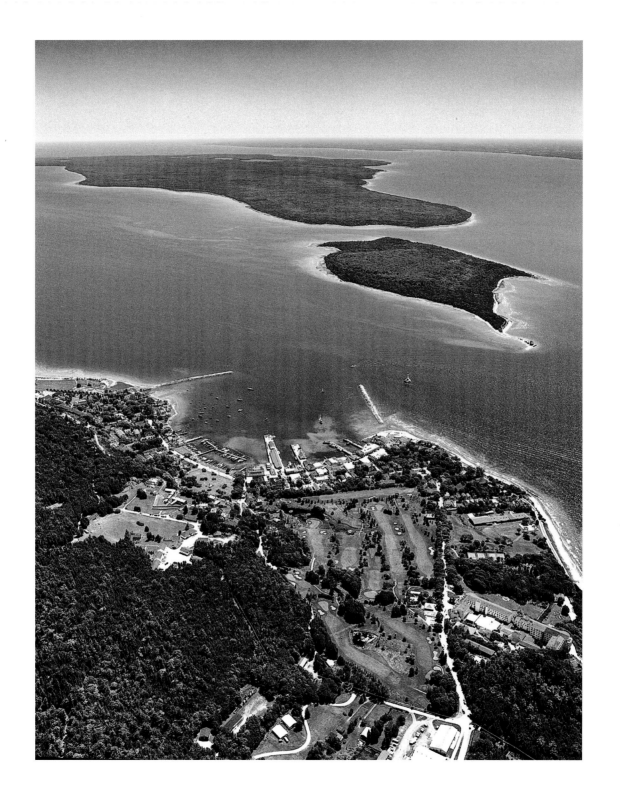

Mackinac Island

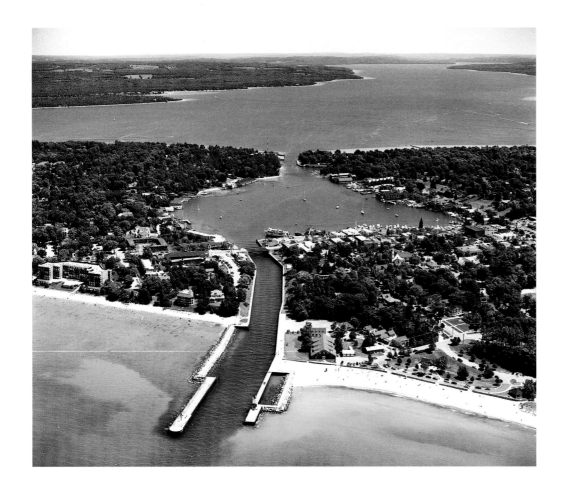

Charlevoix

Hemingway Point

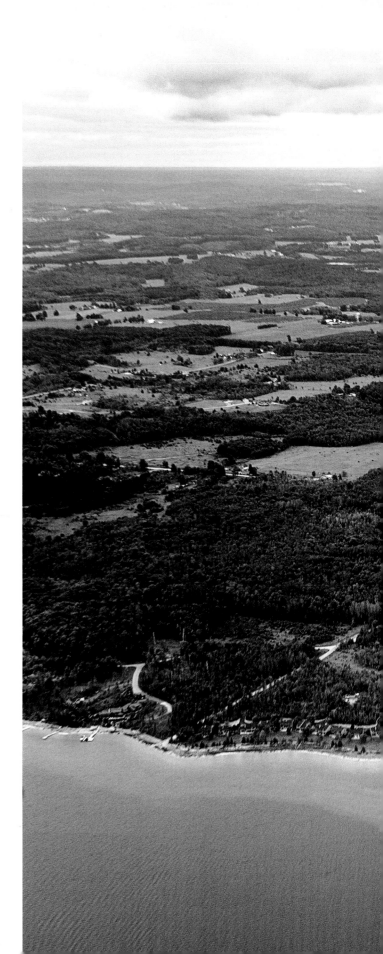

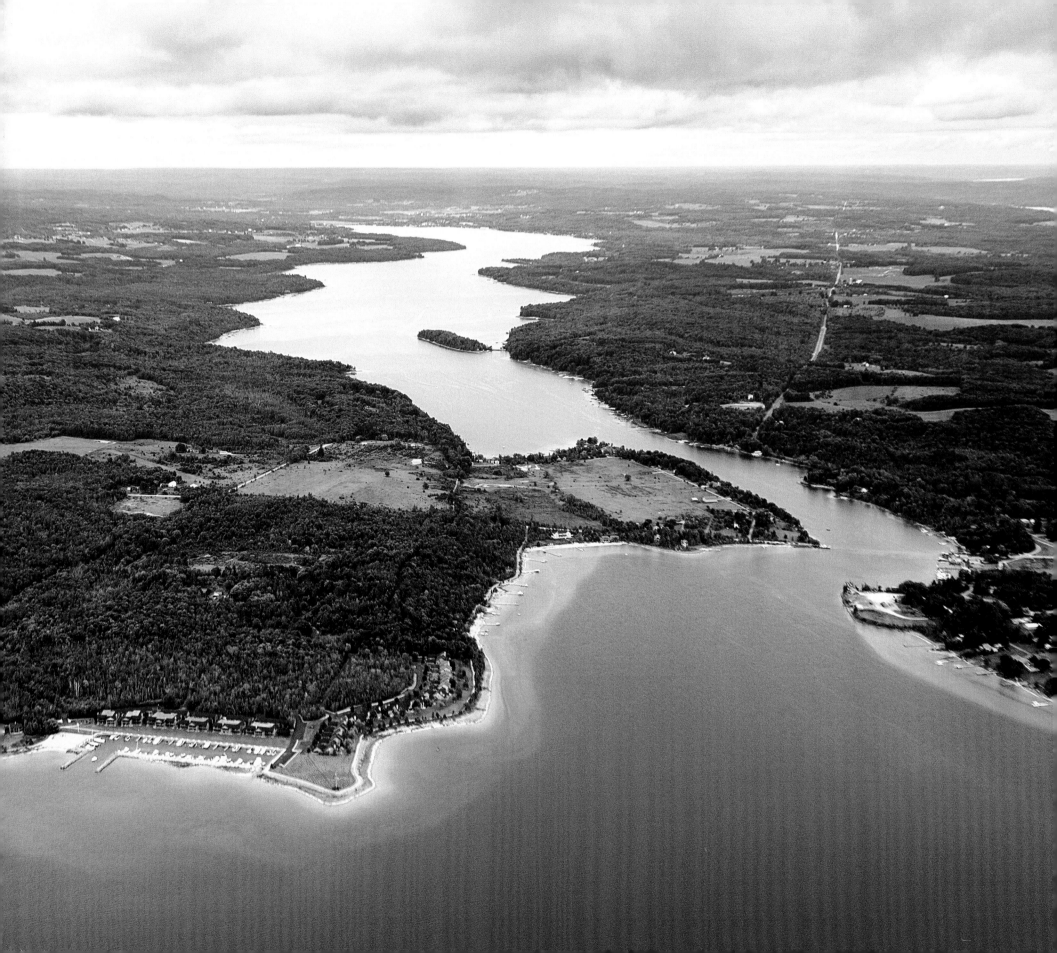